your
family
in pictures

W9-BOM-751

AMPHOTO BOOKS

An Imprint of the Crown Publishing Group

Berkeley

your
family
in pictures

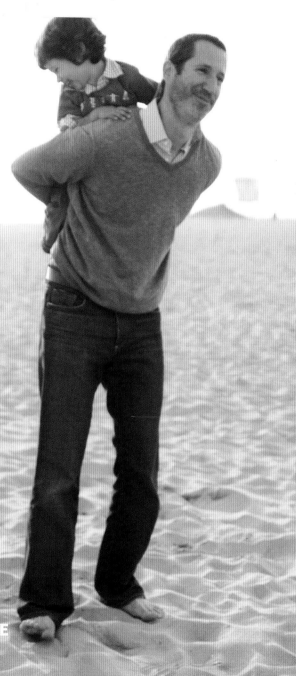

**THE PARENTS' GUIDE TO PHOTOGRAPHING
HOLIDAYS, FAMILY PORTRAITS, AND EVERYDAY LIFE**

ME RA KOH

Published in the United States by Amphoto Books, an imprint of the Crown
Publishing Group, a division of Random House LLC, New York, a Penguin Random
House Company.
www.crownpublishing.com
www.amphotobooks.com

Amphoto Books and the Amphoto Books colophon are registered trademarks of
Random House LLC.

Library of Congress Cataloging-in-Publication Data

Koh, Me Ra, 1973-
 Your family in pictures : forty photo recipes for capturing your family's memories /
Me Ra Koh. -- First edition.
 pages cm
 Includes index.
 ISBN 978-0-8230-8620-7 (trade pbk.) -- ISBN 978-0-8230-8621-4 (ebook)
1. Photography of families. 2. Portrait photography--Technique. 3. Composition
(Photography) I. Title.
 TR681.F28K64 2014
 770--dc23
 2014004777

Trade Paperback ISBN: 978-0-8230-8620-7
eBook ISBN:978-0-8230-8621-4

Printed in China

Design by Jane Archer/www.psbella.com

10 9 8 7 6 5 4 3 2 1

First Edition

to BRIAN, *my husband*
your unending love gives me
confidence to stand tall

acknowledgments

To publish book three in a series leaves me speechless. This only happens because of an incredible team, and words fall short of expressing my deep thanks—but still . . . to Jeff Jochum, my mentor, for empowering "The Photo Mom" vision and envisionly and not just one book but a series. To two incredible editors who bring out my best writing, Julie Mazur Tribe (The Book Studio) and Jenny Wapner (Ten Speed). To our team of CONFIDENCE teachers and former students, your photography and passion for empowering moms adds rich beauty to these pages. To Natalie Mulford, my awesome publicist, and Kimberly Small for all you did to prepare the way. To Stephanie Boozer, your thorough assistance helps me exhale. To Nidhi Berry and Linda Kaplan of Crown's foreign rights department, because of you, translations reach moms all over the world! To Jane Archer, your incredible eye for page design and layout have brought my words and photos to life throughout all three books—I am so thankful for you. To Margie Gilmore and Disney Jr. who champion me with empowering moms and kids through TV. To the Scripps Network team, for believing in our vision to inspire families. To the Sony *Artisans of Imagery*, your support gives me wings; I am inspired by each of you. To all the families I've had the honor of photographing, to workshop attendees, blog readers, mom bloggers, TV viewers (some of who are tucked within these pages) your emails, stories, photos and enthusiasm fill my heart! To all the parents who share my books with friends, I write this series for you to find continuous joy in capturing your family. To my Heavenly Father, my heart is over whelmed with how You restored my family. Most of all, to my beautiful family—the whole lot, what a blessed woman I am with you in my life.

contents

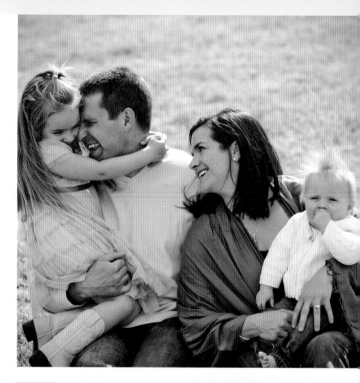

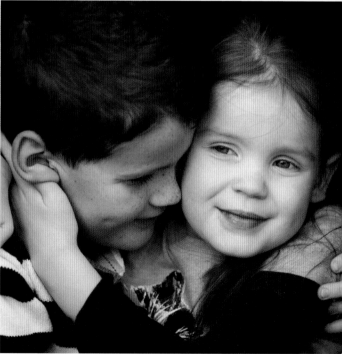

Photo by Amy Rhods

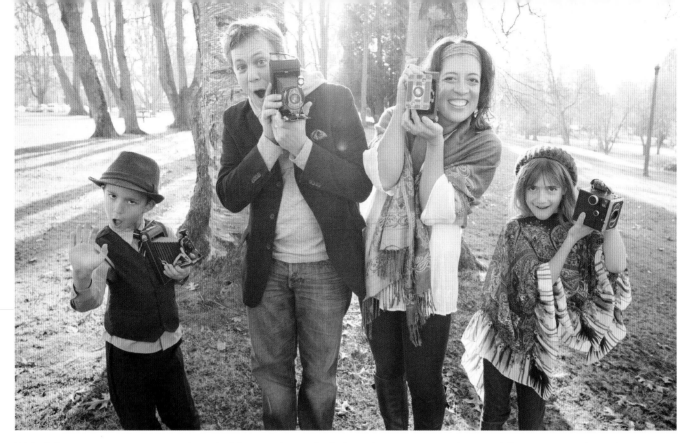

With all the amazing opportunities and wonderful partnerships we've built, nothing compares to the powerful, creative voice that photography has given to our family as a whole.

preface: *my story*

I was speaking in Seattle when a woman came up to me afterward. In her hands she held a well-loved copy of my first book, *Your Baby in Pictures: The New Parents' Guide to Photographing Your Baby's First Year*. She had flown from South Dakota to Washington State not only to hear me speak but to share something special. As she opened the book, I noticed that every single one of the forty photo recipes had a small photo attached that she had taken. She had documented the first year of her baby's life and, with tears welling up in her eyes, wanted to thank me for empowering her to capture moments she never thought possible. Each photo was her beautiful interpretation of my photo recipes. I was so moved by what I saw that she gave me the prints as a gift. Those prints sit on my desk as a visual affirmation to my passion of empowering moms with cameras.

If this is your first introduction to me and my story, I'll start with a shortened version, but I invite you to read more at www.merakoh.com. I often share that I didn't find photography; photography found me, and then it healed me. I started as a writer. My first book, *Beauty Restored: Finding Life and Hope After Date Rape*, was published in 2001, on the same day my daughter was born. The book is based on my recovery from being date-raped. When Pascaline was three months old, we hit the road and did an almost-two-year book tour with the sole purpose of bringing hope and healing to other women who had been sexually victimized.

At the end of those two years, I miscarried Aidan, our second baby. This sudden loss, combined with all the other years of pain in my life, overwhelmed me. I couldn't write or speak. I spent most days on the couch watching Pascaline play with her toys. It was on one of these lonely afternoons that I noticed the afternoon sunlight illuminate her. I knew in that moment that I wanted to capture her and hold on to what was in front of me. I went to the local Costco and bought my first camera, an entry-level SLR camera, and a pack of film.

I had no intention of taking photography beyond a hobby, but life has a way of surprising us when we step into the unknown and open ourselves to a new form of creativity. Friends noticed my photos of Pascaline and asked me to take pictures of their kids. I would shoot two rolls of film and give them the negatives, feeling thrilled to have a creative outlet while my grieving heart healed behind the camera. Soon after, a bride asked me to shoot her wedding. I convinced my husband, Brian, to come with me. That was the toughest wedding we ever shot, but we loved every minute of it. For the next six years we grew a boutique wedding photography business, shooting high-end weddings together all over the country.

But my deepest passion has always been to empower women—especially moms. To impact a mom's life is to impact the whole family. When a mom is inspired to create, she begins to believe she has a voice worthy of being heard. Confidence takes root—and her whole family is forever influenced. After six years of wedding photography, Brian and I turned our business's sole focus to empowering moms so that we might be a catalyst for moms to find confidence with their cameras.

I am amazed at how doors open when we are following our passion. In 2008, I started a wonderful partnership with SONY as one of their Artisans of Imagery. Together we work at finding new ways to empower moms with cameras, while I also represent their family portrait and family travel photography. In 2010, the Nate Berkus Show began flying me to New York City, back and forth, over a two-year period to be Nate's sole photo expert.

Two years later, Disney invited me to partner with them and host a Disney Junior series called *Capture Your Story with Me Ra Koh* in which I visit moms around the country and teach them how to photograph their kids. After five years of selling out our CONFIDENCE Photography Workshops for women (a jam-packed two days during which we teach women how to use their cameras, listen to their creative spirit, and shoot with heart and confidence), Brian and I launched a nationwide teaching program where we mentor and lead over a dozen CONFIDENCE teachers around the country who are now teaching our workshops to moms in their local communities.

With these amazing opportunities and partnerships, nothing compares to how photography has affected our family. Our kids (Pascaline and Blaze) have grown up with cameras in their hands. They know firsthand how powerful it can be. As a family, we have spent a month in Egypt interviewing and filming that country's beauty in the midst of revolution. For six years, we've taken sometimes six weeks at a time to unplug and live in Thailand's jungle with our kids, observing and photographing monkeys and elephants while doing homeschool. From there we traveled to Cambodia's orphanages to teach youth photography workshops. Our kids are experiencing how photography is not only a voice for moms to capture their families but also a way to give voice to the voiceless.

While I'm often in front of the camera as a host on Disney Junior, Brian is now the director and cinematographer for episodes we produce for Disney, SONY, and Target. Together we homeschool the kids and continue to dream big.

My husband, Brian, shows teenagers at an orphanage in Cambodia the basics of operating a camera so that they can capture their stories.

Brian often refers to photography as a vehicle: a vehicle of healing, finding voice, and, especially, building dreams. Our family's days are full, and our dreams are big. But when a four-year-old stands in line for over forty-five minutes to tell me that she and her mom watch me on the Disney Junior channel and that she now loves to take pictures . . . I know my family is doing exactly what we're supposed to do.

In my Disney Junior show, *Capture Your Story with Me Ra Koh*, I have the honor of visiting moms around the country and teaching them simple photo tips that make a night-and-day difference. Along with that, I also get to work with the coolest kids! Rohan and his pet fish are stars in the first season!

Photography often draws those who love technology. And yet, there's another growing population that loves photography just as much: moms and kids. I have never seen myself as a technical person and remember feeling completely lost when I first tried to read my camera manual. It felt like reading a foreign language that would take years to understand, and by then, my family would be grown. That's why I've spent the last five years working on this book series. I want you to be

empowered to capture your family's story, regardless of how technically versed or unversed you may be.

The first two books of this series focus on the pivotal stages of development your baby and child will go through. But there is another beautiful part of life to capture: family life. *Your Family in Pictures* empowers you to capture all the in-between stories your family creates, from everyday moments to holidays and family vacations. As with the first two books, you will read many Me Ra-style explanations that demystify the technical side of photography, along with all the camera settings I used to create the images. In the beginning, I wanted to know the camera settings for every photo until I felt comfortable creating my own. That's why I've provided them for you, along with hundreds of tips and photo secrets.

You will also notice that several of the photos and photo recipes are from my CONFIDENCE teachers or past CONFIDENCE students and blog readers. My intent with this book series is never to wow you with my photographic abilities but instead to infuse you with as much visual inspiration as possible to ignite your own creative eye. Each of us has a story to share. Each of us sees the world in a unique way. Let these 40 photo recipes be a springboard to your own interpretations and storytelling!

Family nourishes, loves, grows, and challenges. Family is the entity that holds all our stories of growing up from nights around the Christmas tree to summer days spent camping out under the stars. Documenting these experiences will be one of the most rewarding gifts you share in years to come. These 40 photo recipes will help you capture moments that will add to the legacy of who your family is, and how it acts, walks, and breathes. Generations to come will take note and be influenced by every photo they see.

Photography is powerful. And even though the technical side can feel overwhelming, let me guide you through my creative process, where technicalities are kept simple so that creativity can breathe. One day, your grandchildren will ask to hear stories of Mom and Dad. You will smile wide. Not only will you invite them to sit on your lap to hear the best stories, but you will have a collection of family pictures that speak for themselves. Your grandchild's creativity will be sparked. And your family's legacy will forever be influenced. This is only the beginning of your journey.

And so the legacy continues of who we are, where we come from, and how we will give. Are you ready to get started? Your family's story is on the edge of its seat, waiting for you to capture it.

Much love,
Me Ra

Brian and I now mentor an incredible, nationwide team of CONFIDENCE photography workshop teachers. They are not only celebrated women photographers but also passionate about empowering moms with cameras in their local community.

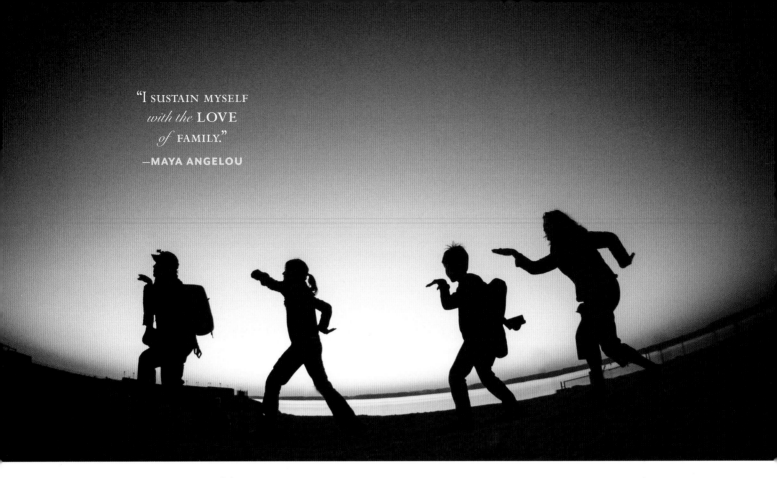

"I SUSTAIN MYSELF *with the* LOVE *of* FAMILY."
—MAYA ANGELOU

Our family waiting to photograph Egypt's sunrise and doing a little *Walk Like an Egyptian* dance while we wait.

introduction

amily is one of the most powerful entities in life. We are shaped by it. We find identity in it. Family has the power to hurt, but it also has the ability to give us unstoppable courage and fearlessness—when we know we are not alone. There is the constant weaving of a tapestry of personalities and passion that creates family.

Family is one of the most beautiful entities, if not the most beautiful, to capture in pictures. Every stage, every milestone, is a chapter to behold. Every new generation is an addition to the legacy we leave behind. And every photo has the potential to speak of the stories that changed us, made us, and shaped us, years after we are gone.

Your Baby in Pictures is about empowering you to celebrate the incredible growth and development that happens in the first twelve months of your baby's life. *Your Child in Pictures* is about helping you slow down, stepping outside of the flurry of taking hundreds of photos and instead focusing on the milestone stories your children experience as one-year-olds to ten-year-olds. *Your Family in Pictures* is about seeing the larger picture, the bigger story, and capturing the legacy that will be passed down to future generations.

As a mom and a professional photographer, I've found the camera has been a way for me to love my family by documenting our many stories. I want to empower you to do the same with some of my best photo-taking secrets. This is why I've dedicated chapter 1 to setting yourself up for success. Before you even pick up a camera, there are a number of things you want to know to avoid common pitfalls and find success with your picture taking. Chapter 2 is all about developing a photographer's eye. Must you be born with a photographer's eye to be great at taking photos? Absolutely not. I didn't even pick up a camera until I was thirty years old. Read along as I share with you some of my best creative practices to see the world through a photographer's eye.

Family is a living entity that is constantly metamorphosing with each new chapter and season in life. It inhales in the beginning when a partnership of two people takes place—and their family begins. It exhales with the birth of each child. It inhales with each passing holiday and exhales with every vacation. This is why I've broken up the book into five sections: everyday life, holidays, family portraits, tweens and teens, and family vacations and travel. Each chapter features

quick tips for photographing that theme and then my signature photo "recipes" to try with your family. Get ready to learn not only the ingredients for taking each picture but also all the secrets and steps behind the photos, too.

Each photo recipe walks you through the following:
- When to take it
- How to prep for the shot
- What settings to use for a point-and-shoot or DSLR camera
- Composition and framing tips
- Where to focus before shooting
- The exact DSLR settings used for the photo shown, including the aperture, shutter speed, and ISO. In fact, you'll start to discover the consistency within the camera settings I use so that you can branch off into your own experimentation.

True to the book series, all 40 photo recipes can be followed with either a point-and-shoot or a DSLR camera; however, point-and-shoots can be incredibly limiting, and if you're sitting on the fence about upgrading your DSLR, I encourage you to check out the appendix to help you make your purchase decision. There are also website links tucked into some of the photo recipes so that you can watch the Disney Junior episode from *Capture Your Story with Me Ra Koh* in which I walk a mom through the exact photography technique in the book.

With each of the books in this series, I'm honored to include powerful, moving, inspiring photos from women I mentor. These women have attended my CONFIDENCE workshops, and a select number have gone on to become a part of our nationwide team of CONFIDENCE teachers—teaching our CONFIDENCE

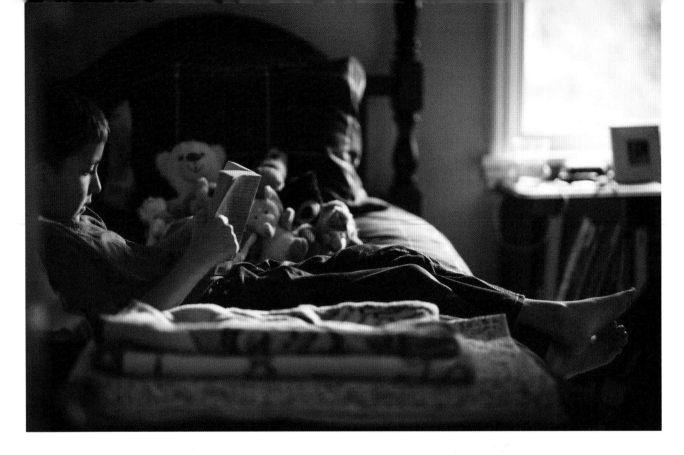

workshops and empowering moms in their own local communities. I am overwhelmed by the honor to play a creative role in each of their lives, and it brings me great joy to share their beautiful work with you! Each one of us sees the world with a different eye. My goal is to help you find your own eye by following the many examples from dynamic, beautiful, creative women throughout this book.

When I think about family, Mother Teresa comes to mind. Family was one of her favorite subjects. During several interviews, she often transitioned the focus from helping the poor in India to encouraging listeners to love their families. When a man from the United States came to work in one of her orphanages, she counseled him to return home and instead do a far

greater work—love his family. With all the suffering she encountered on a daily basis, she passionately believed that the most powerful way to heal the world was to love our families. Maybe it's because she knew that when the foundation of who we are, where we come from, is whole and treasured, we can do anything. We can change the world.

Finding a desire to take pictures of your baby is effortless. Taking pictures of your active child is both challenging and rewarding. Capturing your family in pictures is about creating a legacy to leave behind—a legacy that comes from a place of love and has the power to change the world.

If you're ready to change the world, starting with your beautiful family, grab your camera and let's dive in!

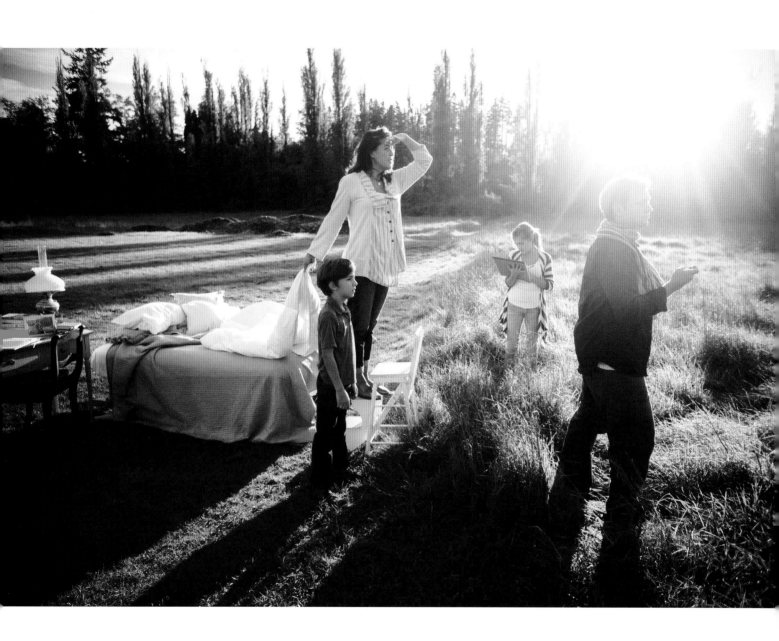

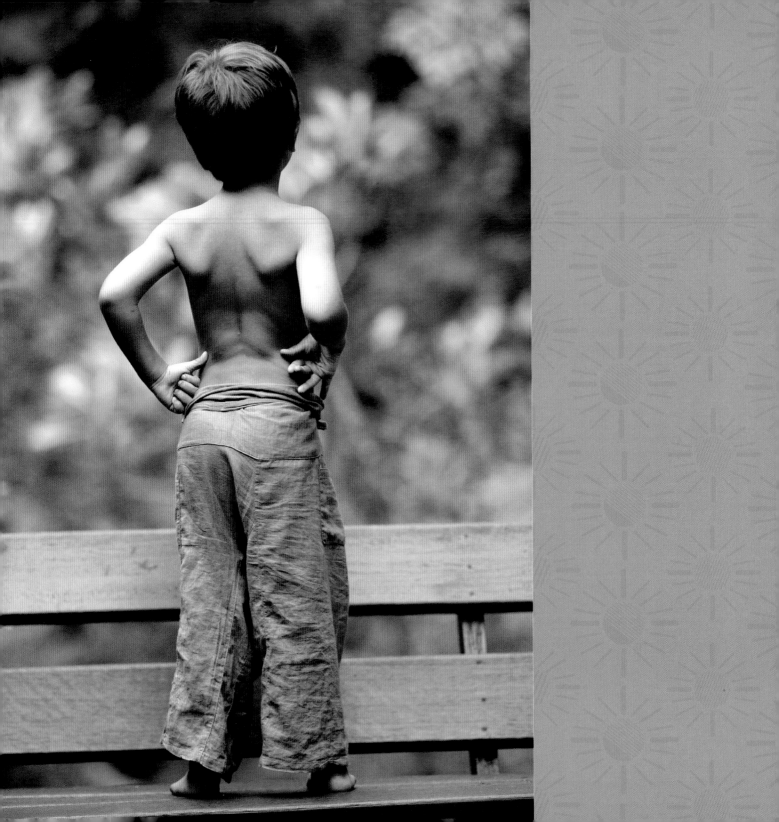

setting yourself
up for success

great photography is all about knowing how to set yourself up for success. When I was a newbie, I assumed professional photographers were like magicians. Their cameras were their magic wands able to capture the most amazing photo at any time of day or night. Years later, I know better. Professional photographers aren't magicians; we just know how to set our photos up for success, and in doing so, we avoid as many pitfalls as possible. One of the most important keys is having the right camera gear for the specific story you're trying to capture. In the first two books of this series, I talked a lot about how to find the right camera for what you want to capture. For those of you who don't yet own those two books, I've included a brief summary in the appendix so that you know what things to look for when buying a point-and-shoot, DSLR, and what type of lens to buy. But first, let's discuss all the things you can do to set yourself up for success before you even pick up the camera gear.

7 spots in your home for great light

Finding the best light is often the difference between good and bad photos. Many times, we get frustrated with our photos because our family is blurred. In most cases, this is due to not having enough light. If you're passionate about photography, you want to develop a passion for observing light: noticing the degree of light, how light changes throughout the day, when it softly spills into a room from the window versus when it is almost too bright and harsh. When we first start taking photos, we often assume the best light is outside. But there are also great spots of light within your home that will give you beautiful results! Be aware of these different spots, and subtly encourage your family to be in them. Or beforehand, you can set up an activity like a board game or toys in these areas. Turn off your auto flash, and have fun experimenting with these seven everyday spots in your home! Once you find them . . . success!

WINDOWS. Window light creates some of the most flattering, beautiful soft lighting for photos. But notice the degree of light by looking at the floor. Before setting your family next to the window, take note of how bright the light is right under the window and how far the light stretches before the light's intensity tapers off. Your family doesn't necessarily have to be right under the window but rather should be at the distance where the light becomes soft versus harsh.

WHITE KITCHEN COUNTERS. I've been known to capture some of my clients' favorite family photos in the kitchen with everyone leaning up against the countertops. The window light bounces off the white countertops, reflecting this beautiful light onto their faces. (And the countertop is a great tool for hiding bodies if parents don't want their whole body in the photo!)

SHEER CURTAINS. I get crazy excited by sheer curtains! They can be the best backdrop to a photo. Their sheer material softens harsh window light, giving an almost softbox look and feel without having to invest in studio equipment! And sheer curtains are super portable if you want to carry one in your camera bag for unexpected opportunities.

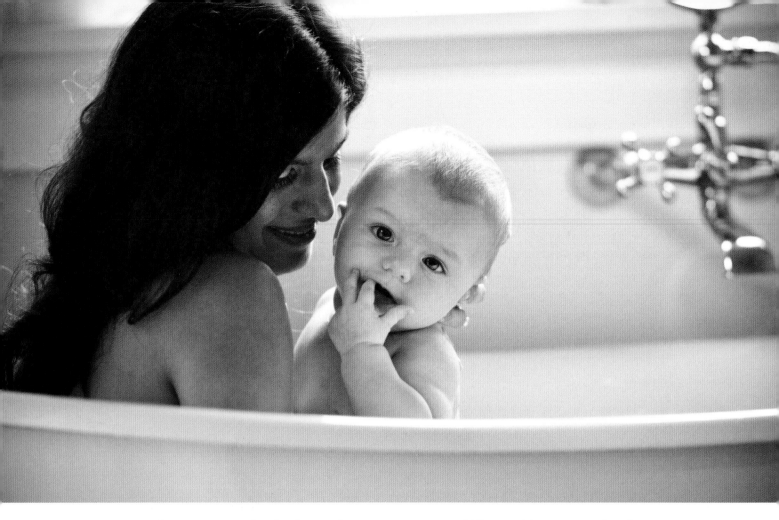

OPEN DOORS. If you want your family photo to have the feel of everyone being inside but you need more light, have everyone stand or sit in an open doorway. The outside light will illuminate their faces while keeping the background dark.

LAMPS. By turning off your flash and using a higher ISO, lamp light can bring a warm look to your photo's story. The key is to turn off all the other lights in the room so that your single lamp is the only light source. This will make the lamp's light much more dramatic and warm in tone versus being diluted by overhead lighting or other lamps.

BATHTUBS. Who would ever guess that the bathtub would be a great place for finding light? But I love doing part of my photo shoots in bathtubs! If near a window, the white, enamel surface acts as a reflector-bouncing gorgeous window light everywhere!

SLIDING GLASS DOORS OR FRENCH DOORS. On cloudy days, have your family sit next to sliding glass doors or French doors for even more light than a single window can give. If you want an even light on all their faces, have them face the sliding glass doors. If you want a partly shadowed light on their faces for depth, have them sit with their sides to the sliding glass doors.

10 steps to set up your photos for success

The two first steps are hopefully determined at this point: you know what camera gear will best capture your family's story, and you know where to find the best light in your home. Now let's talk about what else you need to set your photos up for success. Below are ten steps that I walk through with every photo shoot. When these ten steps are in place, my chances of capturing the photos I want and envision are almost 100 percent!

CHECK AND PREP ALL THE GEAR. There's nothing worse than getting ready to capture a wonderful family moment only to find that your battery is half-dead or your memory card is almost full. This is the fastest way to deflate your family's enthusiasm. Make sure you regularly take time to charge batteries and clear cards.

DECIDE BEFOREHAND WHAT YOUR PHOTO IS ABOUT. Imagine that you're photographing your child and her grandma in a garden setting. Do you focus on both the flowers and your subjects? And how do you do this so that the subjects don't seem lost among the flowers? You must choose one or the other to be your focus, so find the main element of the story in your image, and then let the other elements be a foreground or get in closer.

WEAVE ELEMENTS OF DESIGN INTO YOUR LOCATION. You may be taking photos in the backyard or front yard, but take a moment to look around for interesting textures, repetitive shapes, colorful walls, and all the other things we'll talk about in chapter 2 ("Developing a Photographer's Eye"). These design elements are often in our everyday life, waiting to be uncovered. Where could you move the kids to have surroundings or a background that would enrich the story that much more?

When you have a beautiful setting and subjects you love, it's easy to take a photo with too much background. Decide what your photo is about and get in tight. Remember: Less is more with storytelling.

DECIDE ON TIME OF DAY. Morning and evening light is always more flattering. If at all possible, avoid shooting at noon. At that time, the sun is right overhead, creating Dracula-type shadows under the eyes. People are often forced to squint as the sun blinds them. If you have to shoot at noon, find shade from a tree with thick foliage or look for the shadow from a building.

FILL YOUR RECTANGLE FIRST. Before you even lift the camera to your eye, decide what you're going to fill that viewfinder or LCD screen rectangle with. Pretend you have the miniature frame with you that we talk about in "Practice Framing Daily Moments" (page19). What would you choose to leave in the frame, and what can be framed out to make the story that much stronger?

PRETEND YOU ONLY HAVE THIRTY-SIX SHOTS. Even though you may have a huge memory card that holds a gazillion photos, do you really want that many photos of an afternoon at the swimming pool? Pretend that you only have thirty-six shots to take, which is equivalent to what one roll of film used to be. If you only have thirty-six shots, you've got to pause and ask yourself how you are going to use them.

PICK YOUR IDEAL LIGHTING. Kids are often on the move. They can run circles in the backyard with the light constantly changing, depending on whether or not the trees shadow their faces or the bright sun makes everyone squint. Instead of constantly changing your camera settings while trying to keep up with their changing locations, pick your ideal spot of lighting—where the light is the best. Dial in your camera settings for that spot, and either wait or encourage your kids to go to that spot again and again by making up a funny

challenge. Forget about all the shots you could capture when they're out of that lighting; they aren't worth the time it will take to edit them on the computer. Remember: We have to be willing to miss shots to get great shots.

Pascaline and her friend kept running through shadows and bright sun with their butterfly wings on. Instead of continuously readjusting my camera settings, I found the spot that had the best lighting and invited or waited for the girls to run back through that spot.

KEEP ENERGY HIGH AND HAPPY. Our subjects often reflect how we feel as we are shooting. They can tell when we are stressed or having fun. If you come to take their photos with a stressed energy, expect to get tension back. But if you come with a high, happy energy, your subjects will rise to the occasion that much more. In mentoring moms over the years, I've noticed that the kids shut down if they feel like they're failing when having their photo taken. If Mom stays upbeat, kids feel like the experience is worth it and even fun!

If your little one is full of energy, don't fight it. In fact, catch him off-guard and take it up a notch!

SET A TIME LIMIT. If you know that your family is already burned out on having photos taken, set a time limit with them. Tell them that you're going to take photos for the next thirty minutes and that when they hear the timer go off, you'll stop. This exercise is simple but incredibly powerful in rebuilding trust with family members (who may not share your passion to capture every moment of their life).

AFFIRM THE GREAT JOB THEY DID—AND HOW MUCH IT MEANT TO YOU. When we take someone's photo, we are asking them to give us something. It's important to thank your family for being so generous while affirming how great they were with simple statements like "I love how you acted like I wasn't even there and just let me take photos of you without saying 'cheese'!" Affirmations like this especially help our children learn what we're hoping to gain when we pull out the camera, and in turn, this creates a much freer dynamic of capturing them as they become older.

9 ideas for getting your family in the mood

But what if your family isn't in the mood for taking photos? If you have a less than enthusiastic family, there are special ways to get them in the mood. Below are eight of my favorite methods from my bag of tricks that can often change the grumpiest family member into a giggling participant!

INFORM THE FAMILY AHEAD OF TIME. This tip is so simple and can make all the difference. When my family knows ahead of time that we're planning to do a shoot, their cooperation is night-and-day different; it's when they feel disrupted that they're more resistant.

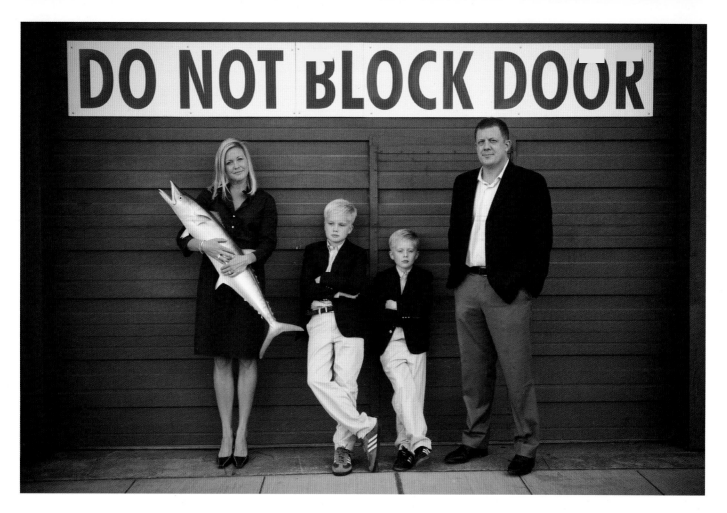

DO NOT BLOCK DOOR

Before this photo shoot, I invited the mom to bring any objects that the family loved. The first thing she thought of was their funny fish that hangs on the wall. When the kids saw mom pull this out of their SUV, a whole new, creative energy and silliness was unleashed for the family portrait!

Inform your family the day or night before you plan to take some family photos; do it with a happy energy in your voice that teases the idea of adventure.

TRY NEW LOCATIONS. One way to add a sense of adventure and fresh excitement to a family photo is by going to a new location. Kids get especially excited with the promise of exploring the new location after the photos are done.

BREAK OUT OF THE TRADITIONAL FAMILY PORTRAIT. There's a certain stiffness to the traditional family portrait, and the experience can often be a mood killer. Why not break with tradition and try something different, even silly?! Involve the unpredictable energy of the family dog or incorporate a favorite family object.

SHARE YOUR CREATIVE VISION. If you have a specific vision for your photos, share this with your family ahead of time. By sharing your hopes with them, you not only elicit their cooperation but also allow the shoot to become collaborative, with much more depth in the setup before the shoot.

INCORPORATE COSTUMES. My family has been in a lot of photos. I mean a lot! When I could tell that we needed to mix it up a bit, I had us go to the local costume store. We picked out a time period, and the kids dressed up as their own character. Pascaline has outgrown the dress-up stage of princess outfits. And Blaze no longer wears his cape everywhere we go. But they both loved the experience of having costumes for a photo shoot.

VERTICAL OR HORIZONTAL FRAMING?

Deciding whether you want your photos to be framed in a horizontal or vertical fashion almost seems silly to talk about. And yet, this simple choice when shooting can make a huge difference in the story you tell. Notice how when I vertically frame the moment, it looks like there is a crowd of kids cheering for Blaze versus the horizontal framing that quiets down the immediacy of the moment.

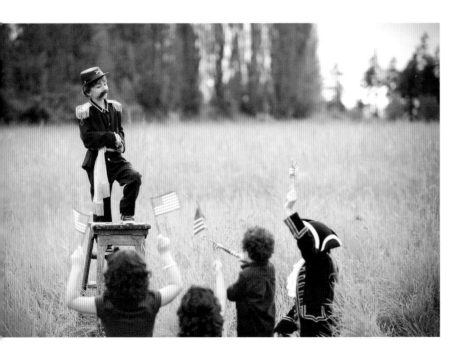

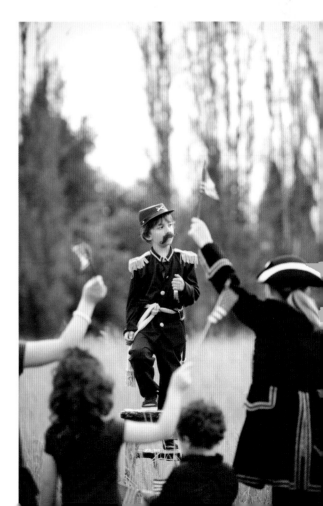

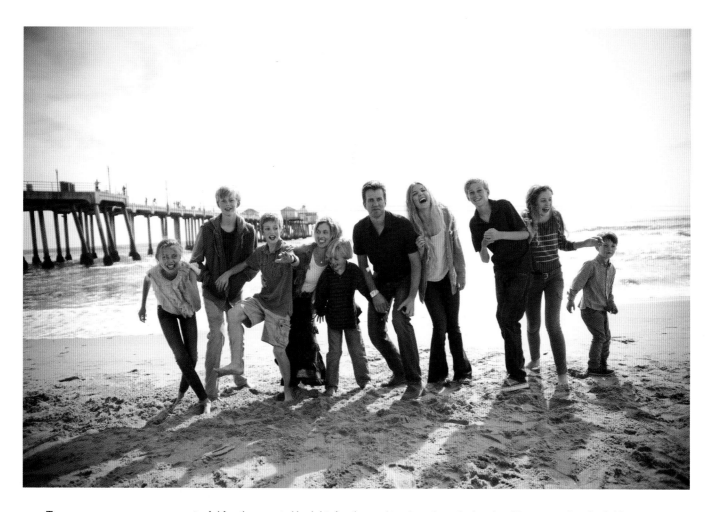

To capture a more spontaneous, joyful family portrait, I had this family stand in a line along the beach in Huntington Beach, California. On the count of three, I told them to all jump and twirl around but land facing me with a smile. This gave us all the best laughs and chased any stiffness or posed smiles away.

MOVE: JUMP, SKIP, AND TWIRL! Along the lines of breaking out of the traditional family portrait, we often find our family standing or sitting for the photo. Why not try jumping, skipping, twirling, or all of them together? The sheer energy that comes from moving our bodies breaks up fake smiles and stiff bodies.

GIVE KIDS THE SPOTLIGHT. Kids often want it, so why not give them the spotlight for a family photo? But give them certain parameters like holding hands with their siblings and jumping on the count of three. Then place mom and dad off-center in the opposite third so that they're still part of the photo but not center stage. This setup lends to everyone getting in the mood for a fun family photo!

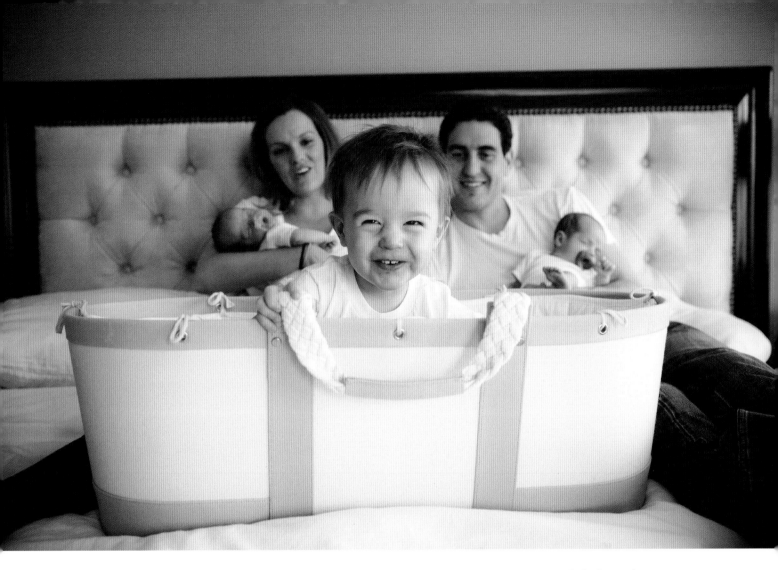

We decided to give big brother a little bit of the spotlight by placing his newborn twin brothers and proud parents in the background.

INCENTIVES. Promising a stop at the local frozen yogurt shop after the photo shoot can't hurt. Based on how cooperative your family is feeling, offer the incentive before taking photos, or keep it as ammunition if things start to fall apart.

LOOK FOR WARNING SIGNS. There are also moments when your family is simply not in the mood. Try not to force it, because they'll be that much more reluctant to participate in picture-taking in the future. See the sidebar on page 15 to know what warnings to look for.

3 ways black and white can transform so-so photos

Black-and-white photography holds a certain power to grab our attention. Maybe it's because most of us see in color; so when we come across a black-and-white photo, we are drawn into a moment that seems to make time stand still.

TIMELESS LOOK. When you find yourself shooting in a low-light situation that requires a higher ISO than you prefer, never fear because black-and-white toning can save the day. The higher ISOs can often create more grain in your photo, but when the image is converted to black and white, that grain accentuates the timeless look and feel.

SOFTENS BLEMISHES. If your newborn has skin rashes or your teenager is dealing with blemishes, black and white can make all those things soften—if not fully disappear.

REMOVES FUNKY COLORS FROM INDOOR LIGHTING. When shooting a family event, there are often challenges dealing with all the funky colors from the lighting that can make your photo look too orange, red, or even green. Changing the image to black and white gets rid of all those horrible color hues and helps us focus on the single moment and emotion captured.

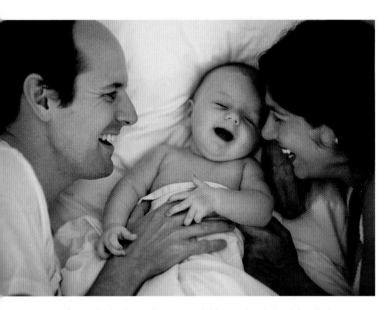

Since the bed wasn't near available window light, I decided to raise my ISO instead of using a flash so that I could preserve the natural lighting of a precious moment.

CONVERTING A DIGITAL COLOR IMAGE TO BLACK AND WHITE IN 3 QUICK STEPS

1. IMPORT YOUR PHOTO INTO A PHOTO-EDITING SOFTWARE PROGRAM. If you don't already have one, you can find free apps online. Target, Walmart, and many drugstores offer a black-and-white editing option in their photo printers. My preferred choice for photo-editing software is Adobe's Lightroom.

2. REMOVE ALL COLOR SATURATION FROM THE PHOTO. This will make the image black and white.

3. INCREASE THE DEGREE OF CONTRAST. By doing this, you make the blacks blacker and the whites whiter. This last step is the key; otherwise, your black-and-white photo can look too gray in tone to have that crisp, clean feel of a dramatic black-and-white image.

my top 10 times to take candid family photos

Everyone loves the family milestone photos at birthdays, the first day of school, or holidays. But there are favorite candid family moments that I love capturing even more. At these times, the photo's story is often relaxed, filled with genuine emotion, and more about the moment we've experienced rather than the event that happened. These are my top ten favorite times for taking candid family photos. Be on the lookout for them in your everyday life.

CUDDLE TIME. There isn't a sweeter moment than siblings cuddling or little ones snuggling into Mom or Dad.

ALONE TIME. All of a sudden you notice the house is super quiet. Grab your camera, and peek around the corner for some great, natural moments when little ones are caught up in their play.

BEGINNING OF A FAMILY EVENT. When family members first arrive, smiles are wide and energy is high. Capturing the genuine sweetness of family members reuniting becomes almost effortless.

EATING ICE CREAM. Kids (and often parents, too!) are so engaged with their yummy treat that the camera becomes invisible.

SUNRISE. When traveling, my family often takes a day to be awake before sunrise for family photos that can't compare to those made at any other time of day.

WIDE-OPEN SCENERY. The scale of how small we are to how large the landscape or scenery can be is a wonderful photo moment. But you want to make sure that the scenery complements the size of the figures and what your family is doing in the photo's story, otherwise the background will become more distracting than accentuating.

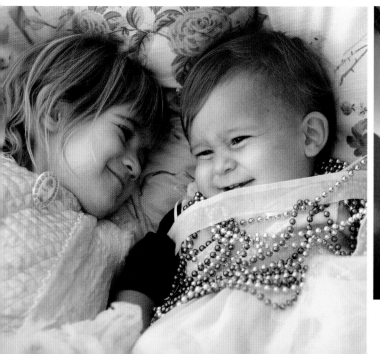

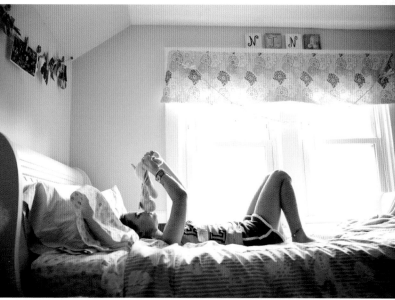

Photo by Jill Ann Melton, a former CONFIDENCE workshop attendee in Texas

LATE AFTERNOON AT THE BEACH (OR ANYWHERE). No other light beats golden, yummy late-afternoon sunlight.

TICKLE TIME. We never forget those family memories of Dad tickling us silly or favorite uncles forcing us to call "Uncle!" Perfect photo moment!

LEARNING. Whenever Brian is teaching the kids something new, or the kids are engaged with a new activity on their own, I love to capture their experience and intense focus.

SILHOUETTES. This family favorite that causes time to stand still. See page 122 for a photo recipe showing how to capture a stunning silhouette.

One of the most wonderful things about photography is that you now have a great excuse for becoming an observer of people and light. Those two subjects have most likely already caught your attention, but as you can see from this chapter, the more attention you pay to people's behavior and the light, the more you set yourself up for success. Great camera equipment is wonderful but useless if you don't know what you are looking for. Give yourself mental exercises to notice the degree of light in different parts of the house throughout the day. Take mental notes of the unique gestures that each of your family members express—to better know how to capture a photo of who they are. These little practices can be done daily, sharpening your eye and creative self for photography. Before you know it, you will find yourself beginning to develop a photographer's eye!

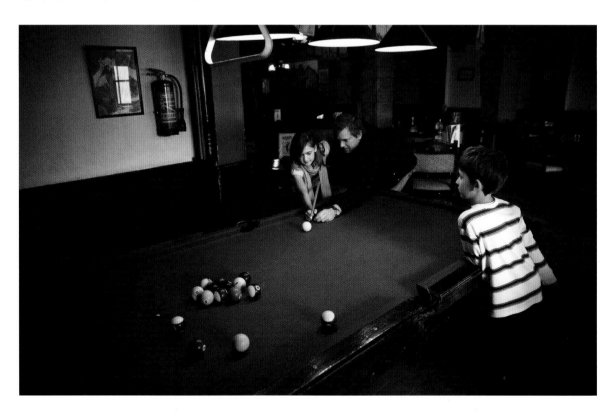

5 SIGNS YOUR FAMILY IS NOT IN THE MOOD

1. THEY'RE HUNGRY. Ever try to take a family photo when everyone is complaining about how hungry they are? Taking photos thirty minutes after a meal or snack makes all the difference in avoiding hungry, fussy kids. If it's a family event, take the photos when everyone first shows up and is most excited to see one another.

2. THEY'RE TIRED. Getting a good night's sleep, or nap time for little ones, will save you so much stress when trying capture moments. If you can tell that everyone is tired, don't force it; wait for a better time.

3. THEY ASK YOU TO PAY THEM. Sounds funny, but I can't tell you how many moms have e-mailed for advice on what to do when their kids ask to be paid for their cooperation with picture-taking! Paying your kids, even the smallest amount, for their cooperation in a photo shoot will only cause more resistance in the long run.

4. THEY RUN AWAY. If your kids run away or hide their faces when you try to take photos, be encouraged that this is a stage. But without guidance, it can last forever. Look to *Your Child in Pictures* for a number of tips on how to help your kids move past this stage.

5. THEY BEG FOR THE LAST SHOT. With digital photography, it's easy to take the same photo a dozen times, even when you don't need to. Family picks up on this right away, and it kills the mood for picture-taking. When you start hearing them beg for the last shot, take it as a sign to wrap it up so that they'll continue to engage with the camera in the future.

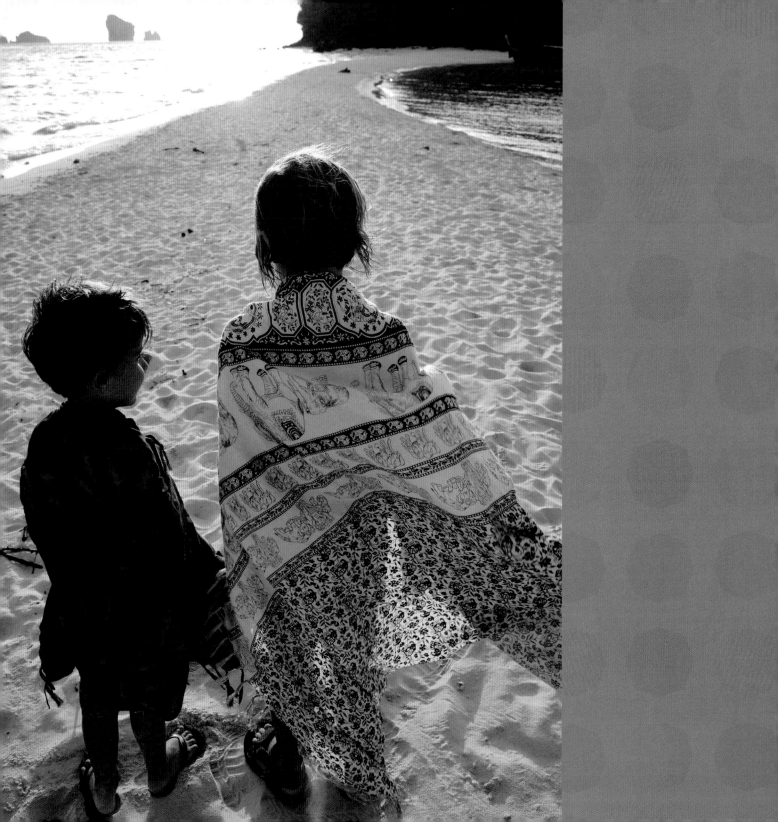

developing a
photographer's eye

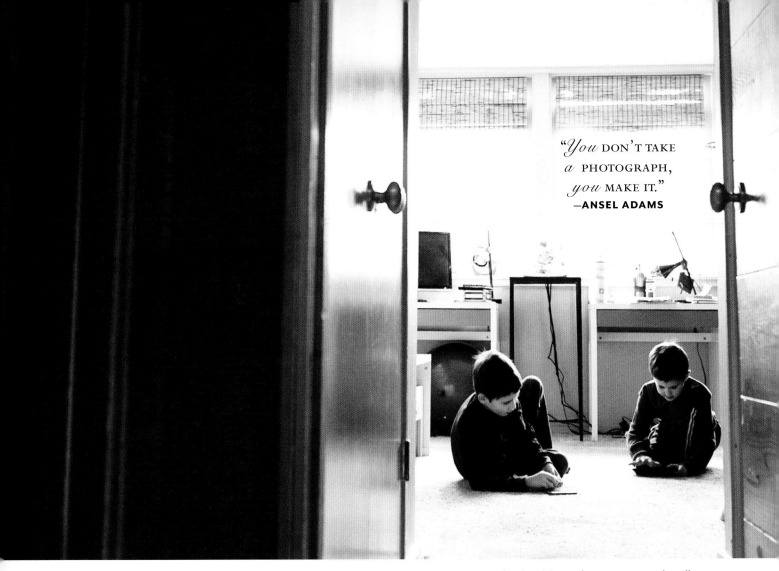

> *"You* DON'T TAKE *a* PHOTOGRAPH, *you* MAKE IT."
> **—ANSEL ADAMS**

A photographer's eye isn't something you must be born with, and it doesn't require a camera to develop. Magic is happening around us all the time; the trick is to develop an awareness of what makes the moment magical.

ave you ever noticed how some photos look professional, while others look like snapshots? What's the difference? As we mentioned in the previous chapter, camera gear plays a role. But much of photography has nothing to do with technical settings and everything to do with color, design, composition, and light. This chapter is going to help you learn how to exercise your creative mind and, in turn, develop a photographer's eye.

practice framing daily moments

When I first started taking pictures, I felt lost. I wasn't sure how to capture the story. I had a solid foundation for storytelling elements from my writing background. I knew "refuse to say cheese" was my motto, but I wasn't sure how that translated into actual frames. Your camera gives you a frame to work with, a rectangle, and you've got to figure out what goes in that rectangle and what stays out. It didn't take me long to figure out that I needed to develop a photographer's eye. In fact, I felt pretty intimidated. I feared that if you weren't born with a photographer's eye, you might never get it. I was pleasantly surprised to find that this trait is something that can be developed, step by step. My process started with a simple 2 x 3-inch miniature wood frame from IKEA.

Take a wallet-size frame and remove the backing and plastic film so that there is a hole in the middle of the frame. Keep it in the car, and whenever you're waiting at a red light, hold it up and think about how you could frame the world around you in that moment. If there are people waiting at the bus stop, ask yourself, "Do I want them off-center or centered?" If you spot a single tree standing in the middle of a wheat field, pull over with your little wood frame and try to figure out where you would position that tree in the rectangle. If a single flower in your garden catches your eye, ask yourself if you want to fill the whole rectangle with that flower or have empty space to one side of it. Through these questions, you are forcing yourself to choose what to fill that rectangle with and what to leave out.

When we first fall in love with taking pictures, we want to capture everything. We overshoot the experience, the story, and the birthday party, and we often end up with five hundred photos of nothing. There's a way to overcome this, but it requires a painful action: choosing—choosing to leave something out. If everything is in the photo, the photo's story is about everything, which essentially means it's about nothing. Carrying around this miniature wood frame will not only help you train your mind to see the world in rectangles but also give you practice in choosing what the story is about. This did wonders for me and our workshop students; I hope it works for you, too!

unpacking a photo

Have you ever had a photo capture you, stop you in your tracks, and leave you standing there in awe wondering how the photographer shot it? I did this all the time. But I couldn't articulate why that specific photo grabbed me. I just knew I loved it. For me to grow in my ability to capture my own great photos, I needed to take the next step in developing a photographer's eye. I needed to develop an awareness of what I loved most in photos. Here are the steps I went through so that you can do this, too.

Before following the steps here, buy a big sketch pad. With a pile of magazines and a bottle of glue, go through magazine page after page, ripping out photos that grab you. Glue the photos down in your sketch pad and do what I call "unpacking the image" by asking yourself several questions:

WHERE WAS THE MAIN LIGHT SOURCE IN THE PHOTO? Once you figure this out, draw an arrow to it and write "main light source" in the margin. If you detect other light sources, number those in order of how bright they are.

WHAT TIME OF DAY WAS IT? Write down your best guess as to what time of day you think the photo was taken.

WHAT WAS THE PHOTOGRAPHER'S POINT OF VIEW? Was she shooting eye level with the subject, shooting down, or shooting up?

WAS THE BACKGROUND BUTTERY, BLURRY, OR IN SHARP FOCUS? How extreme was the blur? Make notes in the margins.

WHAT ARE THE COLORS LIKE? Are they muted, bright, primaries, patterned, or solid colors? With all your magazine cutouts spread over a table, look to see if there are any consistencies in the colors to which your eye is drawn. This will help give guidance on how much of a role you want color to play in your photos.

8 ways to discover color, line, shape, and texture

One of the most rewarding parts of developing a photographer's eye is that once you take a few baby steps, the creative thought process begins to snowball. You go from working hard at framing daily moments with a miniature frame to noticing blurry backgrounds in passing billboards and seeing colors, lines, shapes, and textures jump out at you! Incorporating natural design elements with intention makes a photo's story that much richer. Below are nine different elements of design that I love to look for in everyday life.

POPS OF COLOR. Look for a single "pop" in color to heighten drama. Or consider ways to add your own pop, like a child holding a red balloon in a wheat field at sunset. See "5 Ways to Play with Color" on page 23 for even more ideas.

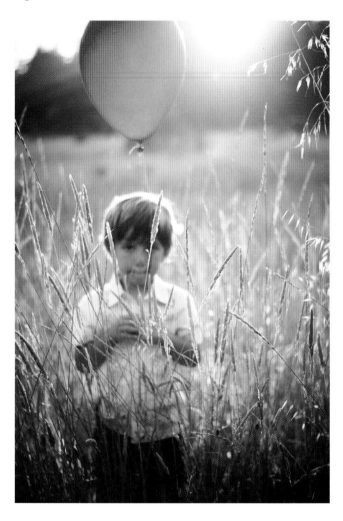

Taking guesses at what the answers could be, writing those notes in the margins, and unpacking every detail you can about each magazine photo helps you develop an eye for what specific elements the photographer chose to use to create the photo's story.

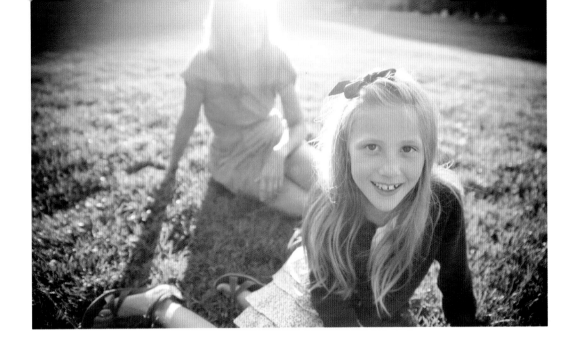

BACKGROUND. Some of the best background colors are found in the most unlikely places! The current fro-yo craze has led to a boom in fun, brightly hued (and often brightly lit) frozen yogurt and ice cream shops.

THE COLOR OF SUNLIGHT. Throughout the day, sunlight evolves into different colors. If you take a photo at noon with the window as your light source, the color of light will be very white. But if you take the same photo in the late afternoon, you'll notice how the sunlight is warmer in tone and color. Visit http://tinyurl.com/merakohsunrisetimelapse to watch an example of how the color of light changed during a sunrise in Egypt. All the color from the sunrise became white right before it became a beautiful blend of orange, yellow, and red hues.

MAN-MADE LEADING LINES. Notice repetitive lines in architecture, often referred to as leading lines. The repetition often leads the eye to a single point of focus.

How can you create a similar story with your family? We walk by these repetitive lines every day without even realizing it: the neighbor's picket fence, decorative wrought iron bars, tunnels, spiral stairs, archways, pillars, stone paths, bridges, the pilings underneath the wharf, and so on.

Photo by Laura Swift, a former CONFIDENCE workshop attendee in Virginia

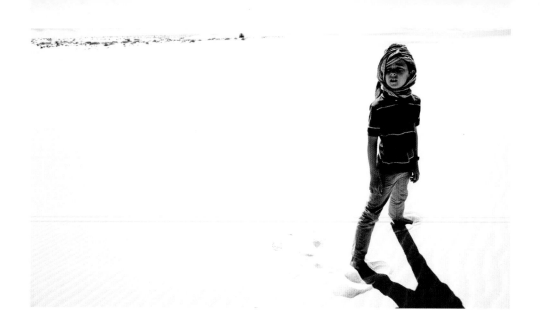

NATURALLY OCCURRING LEADING LINES. Leading lines can be found in natural surroundings, too. They don't necessarily have to be straight lines but can be curves leading our eye to a certain point or out of the frame. Notice how the waves leave a curved line of foam along the sand or the way a stream snakes across the beach reaching for the ocean. How can you position your family in these existing patterns to create even more wonder in your photo's story? Consider tree tunnels, a river's winding path, stretches of wheat fields, rows of sunflowers, or a well-worn hiking path.

NEGATIVE SPACE. Negative space is one of my favorite elements with which to work. In its simplest form, it is the absence of content. This absence of content around your subject brings more clarity, drama, and overall attention to your subject.

THE RULE OF THIRDS. Picture your frame split into nine equal parts; three horizontal sections and three vertical sections. The Rule of Thirds is about composing your image with these sections in mind. Instead of having your subject stuck in the middle, consider framing them in the far right or left section to add more emotion, drama, anticipation. This is especially effective when capturing action. Having your daughter do cartwheels while in the far left third lends much more anticipation, because we know she's moving into the empty space. The one-dimensional photo begins to have a two-dimensional feel. A similar feel results from a subject kicking a soccer ball toward the empty two-thirds of the frame. Following the Rule of Thirds will change the look and feel of your photos overnight.

TEXTURE. Textures are waiting to be discovered everywhere, from brick walls with random shoots of ivy stretching across them to spray-painted alleyways to cobblestone roads to walls with chipped and cracked paint to old sheds with rust spots. In our everyday life, these textures may seem meaningless, but with a photographer's eye, they become magical backgrounds.

In addition to looking for these design elements, experiment with your smartphone and photo apps.

I love to use today's technology to give my creative mind daily exercises. Taking photos of random things that grab my attention and then playing around with the different photo-editing apps both help build a daily awareness of how much variance there is in a single hue or shadow. For example, try taking a single photo of your child at sunset, and then experiment with the different photo-app filters you can use to develop a deeper awareness of what color tones draw you in and what types of lighting you enjoy. Allow your phone to become a way to give your creativity daily exercise while out and about.

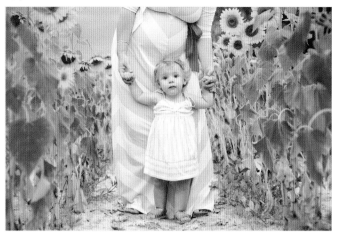

Photo by Jennifer Leigh, a former CONFIDENCE workshop attendee in Georgia

Finally, think of this list as a collection of tools. When you're feeling uninspired, you can pick one of these tools and go hunting for that element with your camera. Take time to look at photos you've already taken. I would bet that you do some of these things intuitively but never put words around it. One of the most empowering experiences is to become aware of creative strengths you already have and then build on them. Before you know it, your photos will incorporate several of these tools in a single photo story!

5 WAYS TO PLAY WITH COLOR

Think of a color wheel to better understand how primary, secondary, and complementary colors work together. This will make you even more aware of picturesque color combinations we see in everyday life, like a pink sundress against a chocolate brown wall or a child with a red balloon in a golden wheat field.

Use complementary colors to enhance a mood. For a soft, quieter look and feel in your photo, think of your family in complementary, muted colors that blend well, differing in subtle tones, rather than wearing clothing with high contrast. For a louder mood, move toward more contrast.

Notice how much contrast there is in nature's colors, from the purplish, pink, and orange sunset set against the black silhouette of houses or mountains to the vibrant coral seen growing in the underwater world against the ocean's muted blue and green hues.

Consider how much of a role you want color rather than emotion to play. A setting like Times Square, with endless colors, will be a big part of the photo's story, feeling loud, busy, on-the-go. But the muted browns, greens, and golds in a meadow can impart a gentle look that draws the eye to your subjects' emotions even more.

Color is emotional. Bright, vibrant hues can often feel more energetic and frantic, while paler pastels and subdued palettes cause us to feel calm and at ease. Dress your family in different color combinations and see how color accentuates the overall mood of the photos.

9 cues for when to shoot (or convert to) black and white

As your confidence grows with the camera's settings, you will find yourself looking not only for light or moments of emotion but also depth in shadows and even darkness. When you first began photography, finding great light was everything. As you develop more and more of a photographer's eye, the shadows, darkness, and overall lack of light begins to draw your creative eye in, too. These elements are what make black-and-white photography so powerful. Look for these nine clues to know when to shoot (or convert a color image to) black and white.

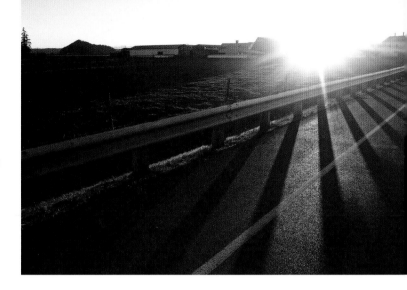

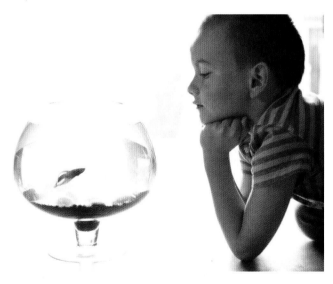

THERE'S HIGH CONTRAST IN TONES. Locations like the beach, desert, and snow-covered mountains have high contrast tones, because there are so many white and light-colored surfaces in contrast with the dark rocks, trees, and the like. A big window in your family room or bedroom can provide a similar high contrast to the darker-toned furniture, too.

THERE'S STRONG BACKLIGHT. Look for light sources to put your family in front of, whether it's a bright window in your home or the setting sun. When you convert the photo to black and white, the strong backlight behind your subjects will add more drama to the overall story.

THERE ARE DRAMATIC SHADOWS. If your family spots their elongated shadows at sunset, or the setting sun is casting long shadows down the road, black and white will help define the shadows' shapes, lines, and curves that much more.

THE COLOR CONTRAST IS STRONG. Just as high contrast between highlights and shadows creates drama, stark contrast in colors can achieve the same effect. Bright reds convert to rich, dark tones in black and white, while pale pinks and blues turn into subtle grays and whites. Look for bold, dark colors against lighter hues or vice versa, such as a light-colored dress in front of a brick wall. For example, a bright red shirt stands out in a light-hued room like a museum atrium. Train your eye to recognize how color contrast translates in black and white.

YOU WANT TO CONVEY A QUIET FEEL. Black-and-white photos have this incredible power to convey a lack of sound. The two contrasting tones tend to quiet all the noise and distraction that color can cause.

YOU WANT TO HIGHLIGHT TEXTURE. If your subject is wearing wonderful textures or the alleyway is brick with chipped paint, consider black and white to draw out these characteristic details.

YOU WANT TO FOCUS ON SHAPES. Use contrast between tones or colors to define edges and shapes. The increased contrast of monochromatic images pulls the shapes of shadows, facial features, and so on into sharper focus. When light more strongly illuminates a face in profile, the features become more defined, and we are drawn into the image even more.

YOU WANT TO SPOTLIGHT EMOTIONS. Whether your subject is overjoyed, angry, or at peace, black-and-white tones help spotlight the emotion. If your photo's story is all about the single emotion of your subject, black and white is a perfect solution.

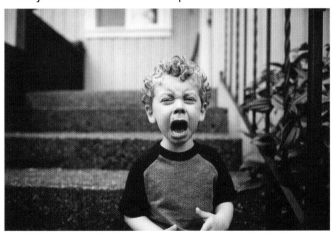

Photo by Tonya Todd, a former CONFIDENCE workshop attendee in Washington State

YOU WANT TO CONVEY A TIMELESS FEEL. The most common reason many of us love black-and-white photos is because of the overall timeless feel they convey. When you find yourself working to capture a photo that is meant to transcend time, consider black and white to enhance it.

TO SHOOT IN BLACK-AND-WHITE MODE OR COLOR, THAT IS THE QUESTION

Most DSLR cameras now have a black-and-white shooting mode. I'm often asked if I shoot with the camera in this mode or color. Until recently, I always shot everything in color and then changed the image to black-and-white in postprocessing the reason being that black-and-white mode results were more grayscale than high contrast in the black-and-white tones. But technology is ever improving, and on a recent trip to Egypt, I shot in black and white while camping in the desert because the high contrast straight out of the camera was that good. I knew that all the desert images would be black and white because of the high contrast, and this saved a ton of time when we were home with thousands of photos to go through. My best advice is to experiment with your camera. How old or new the camera is will determine how high the contrast is in the black-and-white mode.

no longer afraid of the dark

As workshop students become more and more comfortable with their camera's settings, especially with shooting in Manual mode, they often hit a creative wall. The excitement of learning to use their camera has dissipated, and they feel like all their family photos are starting to look the same. This is the milestone when the creative bend in the road is inviting them to come into the dark. As I said earlier, when we first start out in photography, we often look for the best light. But the photos that often move our soul, that hold depth, richness, and an element of mystery—those photos are often taken with the least amount of light.

I encourage you to see how dark you can go in your photos. To do this, switch your camera to Manual mode. Choose the Spot or Partial Metering mode. Set your ISO to 400 (you may need to increase). Choose the lowest aperture number (f-stop) possible on your lens. And then finesse your shutter speed as you determine how little light you can get away with. See page 46 for a photo recipe that will walk you through this process, step by step, when capturing the magic around bedtime stories.

There may be a single light source that is as thin as the crack in a door after saying goodnight to the kids or a single spotlight on a teenage daughter dancing across the dark stage. What once seemed impossible to shoot is now a new creative frontier from which to see the world: to see life in degrees of light, to look for the least amount of light, to let the shadows define the light. That creative wall is no longer a barrier but the catalyst that moves you into the next creative bend.

THE STORY BEHIND THE PHOTO: JULIAN EVANS

"This is a picture of my mother and my grandmother, who is in the advanced stages of Alzheimer's. Most days, she doesn't know who we are. She knows we are 'her people,' because there are pictures of us all over her room. Other than that, she has no memories of us.

"On this day, my mom asked her, 'Do you know who I am today?' and she answered, 'Why don't you tell me.' My mom said, 'I'm Debbie, your daughter.' My grandmother grabbed my mom's face and said, 'And, I'm yours.' It was a beautiful moment. It was clear to us that she really did not recognize my mom. She clung to her baby doll, afraid and looking for something familiar. But despite the fact that this horrible disease has stolen her memories, she could see the sadness in my mom's eyes and she wanted to comfort her."

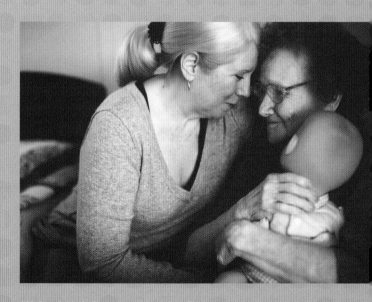

With as little light as possible, Julian Evans uses shadows to enhance the moving story behind this photo of her mom and grandma. Photo by Julian Evans

storyteller vs. photographer

Even though this chapter is all about developing a photographer's eye, I want to conclude it by encouraging you to envision yourself as a storyteller versus a photographer. When you only see yourself as a photographer, your creative process can get stuck around what the camera and technology can do, preventing you from seeing all the stories in your family's everyday life.

In my first two books, I shared a lot about my philosophy "refuse to say cheese and capture the story." The three basic storytelling elements that make up this philosophy are conflict, defining details, and setting with a purpose. Those three elements make a photo's story complete. Sometimes the photo has one element; sometimes it has all three. They serve as a guide to help me refrain from taking hundreds of photos of nothing.

Developing a photographer's eye takes time and practice, much of which doesn't require a camera. You can develop your photographer's eye without taking a single picture. I still practice several of the creative exercises I share in this chapter, and I encourage you to do so also in your day-to-day life of carpool, running errands, and taking walks so that you begin thinking like a photographer all the time, not just when you pick up your camera. If you already have the mind-set of a storytelling photographer when a special moment begins to unfold, wow, wait till you see the results!

This image is a perfect example; when I spotted the tattoos poking out from under the dad's sleeve, I knew this defining detail should play a role in the story of this family. When I suggested the dad take off his

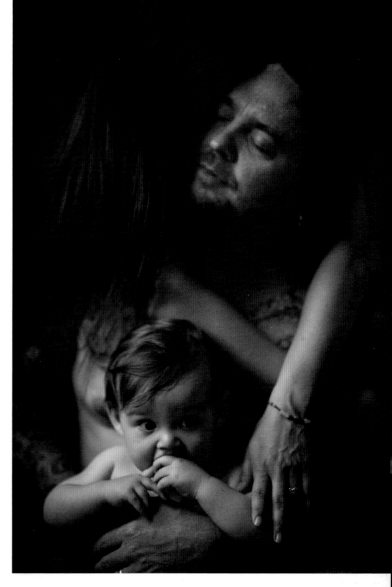

shirt to reveal all the tattoos, they were surprised but also relieved. Instead of having them all look at the camera and smile, we had a wonderful experience working together to capture their truest authentic selves.

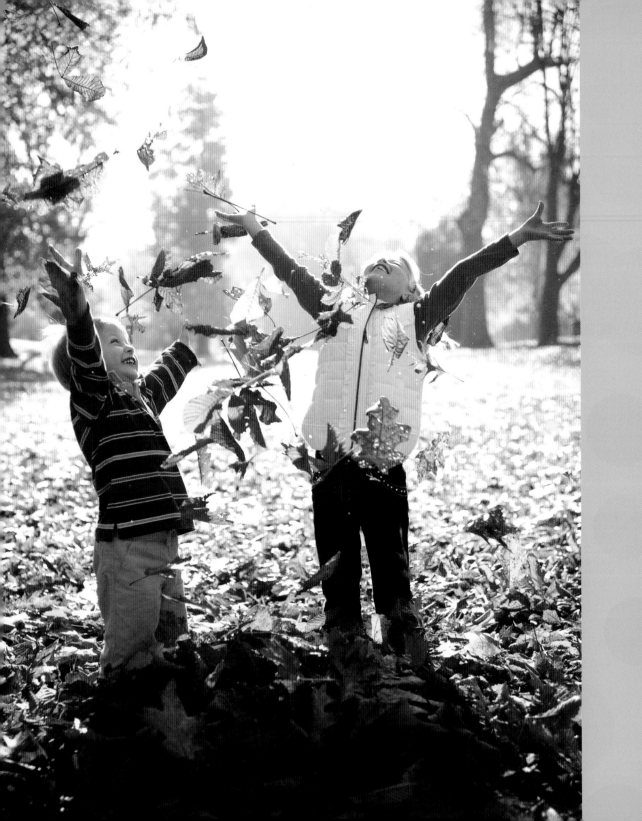

everyday *life*

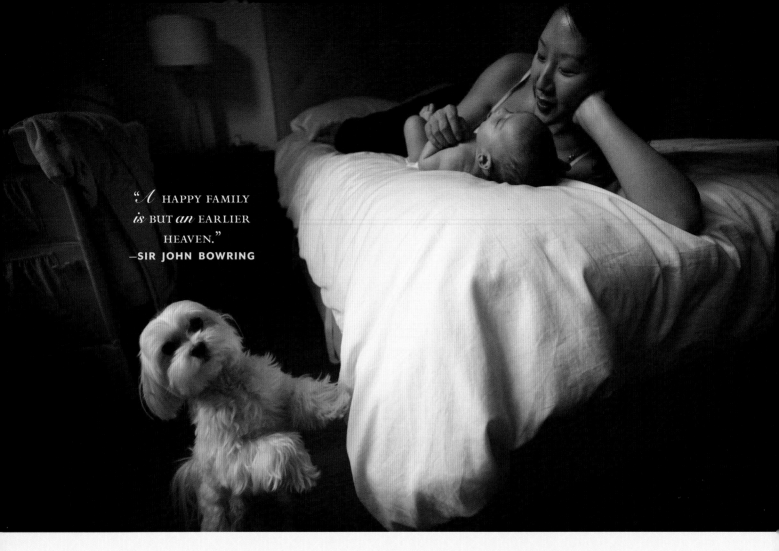

"*A* HAPPY FAMILY *is* BUT *an* EARLIER HEAVEN."
—SIR JOHN BOWRING

Vacations, holidays, and birthdays are wonderful, mountaintop experiences that we look forward to as a family. But the everyday, simple beauty of life is what cultivates the inner person we become. As the kids get older, life feels busier. Chasing the busy toddler turns into driving the carpool with a minivan full of kids. But Saturday morning breakfasts or playing in the backyard with the neighbors on warm summer evenings are all part of the beauty of everyday life that brings us together as a family. The mountaintop experiences are wonderful, but the everyday routines bring comfort, familiarity, and security. What wonderful stories—the ones we can almost take for granted—that we have the opportunity to capture.

five tips
for photographing everyday life

1. **KEEP A CAMERA OUT.** The beauty of everyday life most often happens when we least expect it. Keep a camera out at all times and within arm's reach. This also helps desensitize the family to having their photos taken. The time it takes to get the camera out of the camera bag, find the right lens, and find an SD card and charged battery eats up the patience your family had. But if the camera is there and ready to go, there'll be less resistance to picture-taking.

2. **USE THE CAMERA YOU HAVE.** Don't have your DSLR nearby? Don't worry. The iPhone and other smartphones take remarkably good photos. The best camera is the one you have with you.

3. **SCOPE OUT THE LIGHT.** Be aware of the light in your home. Which rooms get the best light at different times of day? Set yourself up for success by making note of when great light is available

4. **USE CONTINUOUS SHOOTING MODE.** When you're trying to capture everyday moments without putting your family on guard, use this camera mode to quickly fire a few rapid shots in succession rather than taking one image at a time.

5. **CHOOSE YOUR WEEKLY STORY.** Consider upcoming events of the week (baseball game, ballet class, backyard movie night, or play date at the park). Choose one event to work on capturing. Begin to picture how the event will unfold and what the best photo ops could be. Trying to capture ALL events will burn you out, but honing in on one becomes a fun, inspiring photo challenge.

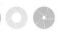

saturday mornings

Saturday mornings can be a blur: breakfast to start, baseball games to get to, cartoons to watch, and heaps of laundry to do. Parents long for another hour of sleep but find themselves attacked by kids jumping on the bed, energetic, fresh and ready for the day's adventures to begin. Why not take advantage of the beautiful morning light and all that exuberance by capturing some action shots of your children being children? Your camera settings can help tell the story: here, a slower shutter speed adds movement by blurring the spin. Dress and hair flying mid-twirl—with a cute little belly button peeking through, this shot is all about movement.

WHEN: Any lazy Saturday morning when kids are just being kids and want nothing more than to jump and dance on the bed. Preferably after a little breakfast so that everyone's fueled up and ready to play.

PREP: Choose a bedroom with ample morning light flooding in from a nearby window. Since this photo recipe involves intentional blur, we want everything that isn't moving to be sharp. To achieve this consider one of three options to steady yourself: use a tripod, lean against a wall, or find a small table against which you can brace your elbows. Put extra pillows on the floor along the bed in case any monkeys fall and bump their heads.

FOR P&S USERS: Turn off the flash. Then set the camera to Portrait mode to get a lower aperture setting, or consider using Night mode (without the flash) to get a slower shutter speed for a nice motion blur.

FOR DSLR USERS: Experiment with setting the camera to Shutter Priority mode and choosing a slower shutter speed like 1/80 sec. (80) or even 1/60 sec. (60), which is the lowest speed at which most people can handhold without getting blur from camera shake. These shutter speeds are also slow enough to capture motion blur from sudden, fast movement (like kids jumping on the bed).

COMPOSE: A horizontal format works well here, because it gets a lot of the storytelling aspects of the bedroom into the frame, like piled laundry and stacks of blankets. This photo's story isn't about being perfect but about the beautiful craziness of a Saturday morning. However, a vertical format could also work if, say, you were at the foot of the bed, so play around with both. Use the Rule of Thirds (page 22) to line up your child or children in the scene.

CAPTURE: Find a chair or kneel on the floor to get slightly below the action and angle up. Because this shot is about movement, focus on your child's midsection (this will also help set exposure if your subject is in front of a bright window-so that they don't become a silhouette). If your child isn't in the center of the frame, reframe and lock focus. Then return to your original composition and fire.

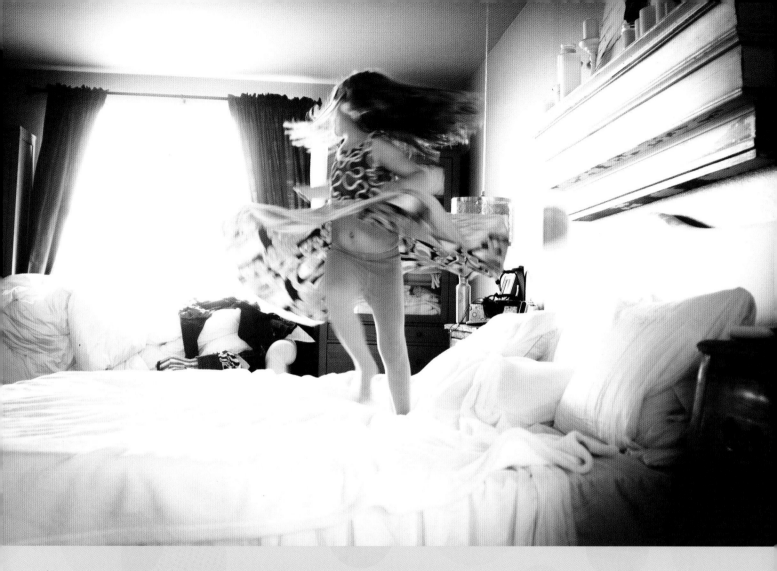

CLOTHES AND BEDDING

To accentuate the story of blurred movement, have the kids dress in clothes that are light and twirl easily. Dresses, capes, light-material nightgowns are all wonderful for adding more motion. Light-colored clothes will also reflect the window light much more, which can add another dimension of depth to the overall photo story. White or light-colored solid sheets will also keep attention on the child rather than on patterned sheets that may be distracting to the action.

My DSLR Settings: Aperture was low: f/2.8. ISO was set to 800 to maximize the ambient window light. Shutter speed was 1/80 sec. (80) to capture motion blur.

breakfast or mealtime

There is a new independence found when a child has breakfast alone. The rest of the family may have already moved on with their day, or maybe your child is just an early bird. Whatever the scenario, grab your camera, because this is one of the few moments in the day that he's sitting still. The big table in comparison to the small body is a potent photo story in itself. Kelli Kalish, a former CONFIDENCE workshop attendee in Illinois, shows how even the simple meal of cereal in a bowl becomes a moment to cherish. By getting down to eye level, Kelli made the lines in the table that much more prominent-leading our eye straight to her son.

WHEN: A leisurely weekend breakfast, or any time that a meal or snack isn't rushed. Invite your child to sit at the head of the table and enjoy his food, and not to focus too much on you and your camera.

PREP: Sitting at one end of the table, as Kelli did, gives you unique perspective as the table surface leads the eye into the center of the frame—and also serves as a stable surface on which to place the camera when using slow shutter speeds (preventing blur from camera shake). If you don't have large windows around your table, turn on all of the household lights available.

FOR P&S USERS: Turn off your flash to avoid harsh shadows. Set your camera to Portrait mode for a nice blurred background and to keep focus on the face. Consider using black-and-white mode if available, especially if you have to rely on interior lighting (which might create an unwanted coloring in skin tones).

FOR DSLR USERS: Turn off the flash. Select Aperture Priority mode, and set the aperture number low, f/1.4 or f/2.8, to soften the background details and let in the most available light possible. Consider converting the image to black and white, which will remove any unwanted color casts from incandescent lighting.

COMPOSE: The horizontal format capitalizes on the expanse of table space in the foreground, leading the focus right to the subject. Pay attention to any backlighting that might come from windows behind the subject. Wait for a moment between bites, to prevent any unflattering chewing shots, and ask your child to look both at the camera and away from the camera for a variety of facial expressions.

CAPTURE: Focus on your child's face. If it's not centered in the frame, reframe your image to center it and lock in your focus. Return to the original composition and fire.

HOMEWORK IN PICTURES

The daily routine of getting homework done is a big part of everyday family life. Watch for a time when your child is focused on her studies, and use the directions from this photo recipe to compose a wonderful shot of the dining table in the foreground leading up to your child.

DSLR SETTINGS: Aperture number is low: f/2.8. The background window light was bright, with some shadows on the subject, so Kelli set her ISO to 200. Shutter speed was a slow 1/30 sec. (30). Photo by Kelli Kalish

heart of the home

The kitchen is the heart of the home. Everyone meets in the kitchen throughout the day, whether it's to search in the fridge for a midday snack, get dinner going, catch up on the day's events, or bake cookies together. Conversations unfold freely, and messes are made easily. When the kids were younger, they loved any opportunity to be my little helpers. It's wonderful to get a photo of them in action, but why not try to capture a family photo of everyone working together?

WHEN: The time of day when you notice that the natural window light is the brightest and most abundant in your kitchen—and the kids are rested and ready to help you with a cooking project.

PREP: Pick something to bake or cook that enlists everyone's help. Prepare as many of the ingredients as possible, separating them in small bowls so that when you are ready to take the photo you can focus all your attention on guiding the little chefs. Find aprons for you and the kids to wear for an additional consistent element that ties everyone together in the photo. Get chairs for the smallest ones to stand on. And clear away any clutter in the background or on countertops that may distract from the overall story.

FOR P&S USERS: Turn off your flash and set your camera to Landscape mode. This mode will help ensure that everyone is in focus versus just one person. However, the point-and-shoot camera will limit your control of the light. You may end up with a darker photo. If this is the case, brighten the image later with a free photo-editing software program.

FOR DSLR USERS: How much light you have will determine how low you can go in your ISO. Windows surrounded this kitchen, and we also had a white marble countertop that bounced light onto our faces, which made ISO 400 possible. Darker kitchens will require a higher ISO. Set your aperture to f/4.0 or f/5.6 if there are more than two people in the photo. This will ensure that the one or two kids in the background will be more in focus rather than blurred. Adjust your shutter speed depending on how much light you have. If your camera is sitting on the kitchen countertop, like mine was, you can get away with a slower shutter speed and the self-timer.

COMPOSE: A horizontal frame works best so that everyone can be included in the one photo. If you don't have another adult at home to help take the picture, set the camera on the counter and tilt it upward. Choose a higher f-stop (f/4.0 will do the trick) so that everyone will be in focus. Position your bodies close together so that you're all in the frame. Set the camera on a timer and jump back in the photo.

CAPTURE: Focus on an object, like a mixing bowl or rolling pin, that's sitting in the middle of the counter between you and the child closest to the camera. As long as you stay close to or on the same plane of focus as the bowl, you will all be in focus.

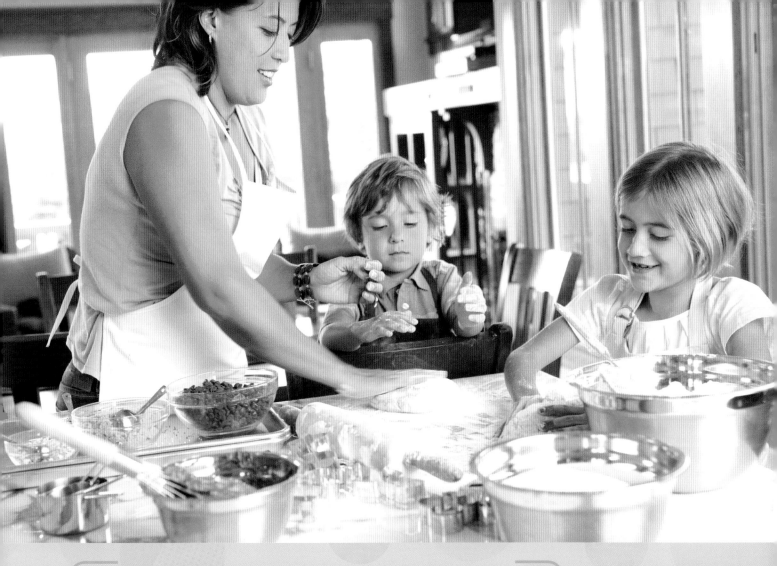

WHITE BALANCE WITH HARDWOOD FLOORS

When shooting indoors, especially in a kitchen with hardwood floors and orange-toned cabinetry, there tends to be a lot more orange in the color of the photo. I often set my white balance to Auto and correct the color with editing software instead of trying to pick the right white balance at the moment. Cloudy or Shade white balance settings will only make the photo look more orange. And time spent on trying to perfect the white balance is time lost with my kids.

MY DSLR SETTINGS:
Aperture was set to f/4.0. ISO was 400. Shutter speed was 1/50 sec. (50). You can take photos of the kids baking, but why not make it a family moment? Prop your camera on the countertop, a stack of books, or the flour canister. Then set the self-timer and jump into the fun!

video games

What could be more a part of your everyday family life than video games? Whether we like it or not, for most of us it's the truth. The upside is how much fun the adults have playing with the kids! One of the kids' favorite things to do during family gatherings is challenge the aunts, uncles, cousins—even grandma—to a racing game or dance-off. The facial expressions that happen are hilarious, and since everyone is so focused on winning . . . no one will notice you sitting right in front of them to take the photo.

WHEN: Any time family is gathered together and different generations are going against one another. Or a time of day when your window light is bright and the kids are playing video games.

PREP: Encourage the adults to sit or stand in between the kids. This helps balance difference in height and size.

FOR P&S USERS: Turn off your flash. Set your camera to Portrait mode to ensure a softer background and sharper focus on your subjects. Choose Continuous Shooting or Burst mode to catch as many facial expressions as possible.

FOR DSLR USERS: Turn off your flash. Set your camera to Aperture Priority mode, and pick the lowest f-stop possible to allow in the most light. You may need to raise your ISO if your photos are picking up motion blur from a shutter speed that's too slow. The shutter speed in this photo is too slow for my comfort, because sudden movement in my subjects may cause blur. A safer shutter speed for subtle movements is 1/125 sec. (125), unless your camera or lens has an image stabilizer feature that you can use to shoot even slower-like I did in this photo. Set your camera to Continuous Shooting mode or Burst mode to capture every funny facial expression you see.

COMPOSE: A horizontal frame worked well for this photo because it allowed for both kids and their cousin to be evenly positioned within the frame. But if your family is standing and doing a dance-off, a vertical frame might make better sense.

CAPTURE: Focus on the family member in the center of the frame. If they're all sitting on the couch, they will most likely be within the same focus plane. But our eye looks to the person who is in the center and closest to us, so that's a good place to lock your focus.

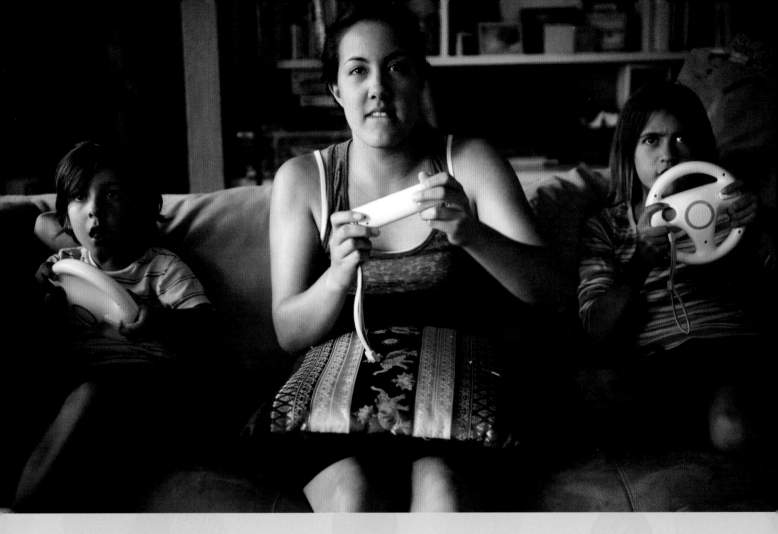

USE BLACK AND WHITE TO SIMPLIFY YOUR SURROUNDINGS

Black and white can come in handy when you want all the attention drawn to the emotion and facial expressions rather than to the items in the background. For this photo, even though I blurred the bookshelves in the background, they were still distracting from the facial expressions when the photo was in color. But black and white made all those distractions go away. See page 12 for three quick steps for converting a color image to black and white, and page 24 for nine cues for when to use black and white.

MY DSLR SETTINGS:
Aperture was set to f/2.8. ISO was 200. Shutter speed was 1/60 sec. (60).

backyard fun

The backyard can be one of the most magical places on earth. In the safety of its borders, kids play dress-up as they create magical worlds. They run through sprinklers, build a swing with Dad, practice soccer. Cathy Mores, a former CONFIDENCE workshop attendee in Kansas, set out to capture how much her client's children love their backyard. It's an everyday setting we almost take for granted and yet such a cherished place to photograph. Consider how you can capture not only the magic that happens in your backyard but the setting as well.

WHEN: In the early evening, when the sun creates long shadows and the light is golden and soft.

PREP: Scope out your backyard earlier in the day so that you know what vantage points will give you the most to work with compositionally. Let your children know you are going to capture the backyard and want them to pretend like you aren't there. Encourage them to do their favorite activities, whether that's playing ball, swinging, or running through sprinklers. Find a good spot, and just camp out long enough for them to forget about you.

FOR P&S USERS: Turn off the flash. Select Landscape mode so that you'll have a greater depth of field if you have multiple children in different places. If you have a lot of movement going on, set your camera to Continuous Shooting mode so that you don't miss a second of their facial expressions or actions.

FOR DSLR USERS: Turn off the flash. Select Aperture Priority mode, and choose a higher aperture number, like f/5, to keep detail sharp if you have children in the foreground and background. Play around with ISO until the photo is bright enough while keeping the shutter speed fast enough to freeze movement. Use Continuous Shooting mode to fire repeatedly if children are running.

COMPOSE: A horizontal format works wonderfully for shots that will include a bit more of the surroundings, because it offers more space to fit in those details. Frame wide enough to include important storytelling elements, like a play set or maybe a portion of a backyard fence—defining details that let us know it's your backyard. A wide frame also ensures there is enough room for moving children to stay in the frame, such as with the girl kicking around the soccer ball.

CAPTURE: Focus on the child closest to you. If she's not directly in the center of the frame, reframe to center and lock focus; then return to your original composition and fire. If you have more than one family member in the photo, experiment with your focus. Consider which point of focus helps tell the story best.

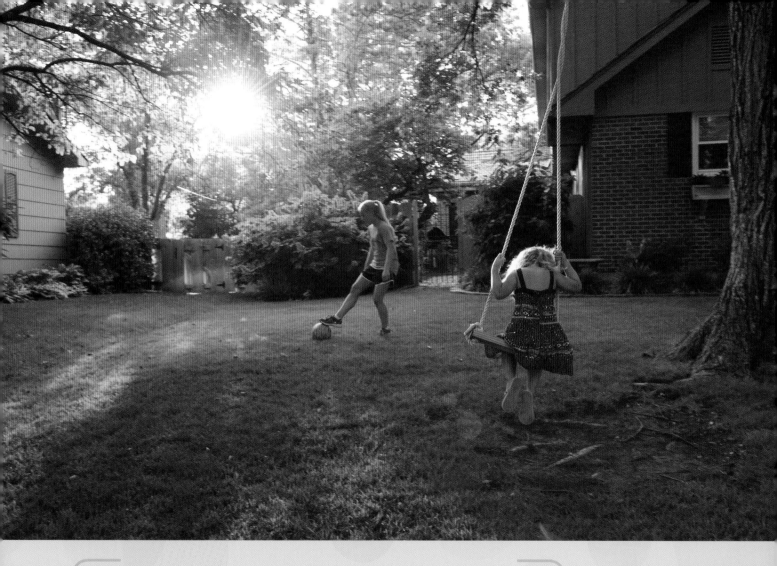

FIND YOUR SWEET SPOT

The light in your backyard can vary depending on where your subjects are standing. You can make yourself crazy trying to fine-tune your camera settings as kids run from the shade to bright sun and back to the shade. Instead, find your sweet spot where the lighting is magical. Wait for the kids to run to that spot, or even encourage them to. Shoot away. When they leave, give yourself permission to miss the shots as you wait for them to come back into the magical light. We have to be willing to miss shots to get great shots.

DSLR SETTINGS:
Aperture was medium-sized at f/5.0 to preserve detail. ISO was set to 500 in fading light. Shutter speed was 1/100 sec. (100). Photo by Cathy Mores

outdoor sports

Getting good pictures of your kids in competitive sports can seem like a challenge, particularly when you don't have control over time of day or location. But you can do a little homework to improve your odds. Elizabeth Wendland, a former CONFIDENCE workshop attendee in Oregon, is incredible with capturing sports. One of her favorite secrets is to find out as much as possible about where the event will take place so that she can scout out good shooting spots ahead of time.

WHEN: During a competition when light is plentiful and the sun is not directly overhead. Overcast days or late afternoons are optimal.

PREP: Familiarize yourself with the sport, event location, and terrain as much as possible. Select a position well in advance, making sure you'll be in front of the action rather than behind it—either behind the goal, on the track straightaway, or at center court for tip-off—and stay there. If possible, figure out where the sun will be at that time of day.

FOR P&S USERS: Turn off the flash. Set your camera to Sports mode for faster shutter speeds that will freeze action. Turn on Continuous Shooting mode so that you can take several frames per second to avoid missing the moment.

FOR DSLR USERS: Turn off the flash. Select Shutter Priority mode, and set the shutter speed to at least 1/400 sec. (400), which is a good setting for capturing common sports movements such as running and throwing. Use Continuous Shooting mode to shoot several frames per second as contestants pass.

COMPOSE: Choose either vertical or horizontal framing depending on the sport, as both often work well. Vertical framing adds energy and is better for close-ups. Horizontal framing lets you show more of the scene, such as the direction the athlete is heading.

CAPTURE: Find a focus point that's easy for your camera to hold, such as the high-contrast numbers on a uniform. Lock focus there, and follow your subject till you see the composition you like and fire the shutter.

FREEZING ACTION WITH SHARP DETAIL

To stop a ball without blur or capture detail in faster sports, you'll want to make sure your shutter speed is at least 1/500 sec. (500) or higher. Also, spend a few extra dollars to invest in an SD card that's designed for capturing fast action. I recently partnered with SONY and Target on a special SD card that is built especially fast for freezing action. These are available exclusively at Target.

DSLR SETTINGS: A low aperture number of f/2.8 softens background details. ISO was set to 640 to allow for a faster shutter speed of 1/500 sec. (500) to freeze the action. Photo by Beth Wendland

out and about

Some of the best everyday moments are when we surprise our kids. A spontaneous trip for ice cream or fro-yo always knocks their socks off. Their sheer excitement brightens the energy of the whole family, as our cares are temporarily set aside to enjoy a yummy, unexpected treat. The emotions that come from this everyday excursion are worth capturing, whether it's toothless grins or everyone just feeling content to sit on the curbside with a cone in hand.

WHEN: Late afternoon or after dinner when light is just starting to fade but is still warm and golden.

PREP: Have your family line up on a bench or street curb, enjoying their ice cream cones, fro-yo, or any other yummy treat. Seat Mom or Dad farthest from the camera, and squat down to eye level.

FOR P&S USERS: Turn off the flash. Set the camera to Portrait mode to achieve gentle blurring in the background.

FOR DSLR USERS: Turn off the flash. Select Aperture Priority mode, and choose a lower aperture number, like f/2.8. This will keep your first child in focus but soften the faces of your family as the line extends back. If it's bright enough, keep the ISO low for best color saturation.

COMPOSE: Vertical framing helps "stack" up family members through the frame. Standing at a slight angle from everyone creates a line from front to back. This guides the eye past each face, eventually toward Mom or Dad at the end, slightly off-center. Play around a little with angles and heights until you get the flow you like.

CAPTURE: Focus on the closest face. If it's not centered in the frame, reframe to center, lock focus, and return to your original composition and fire.

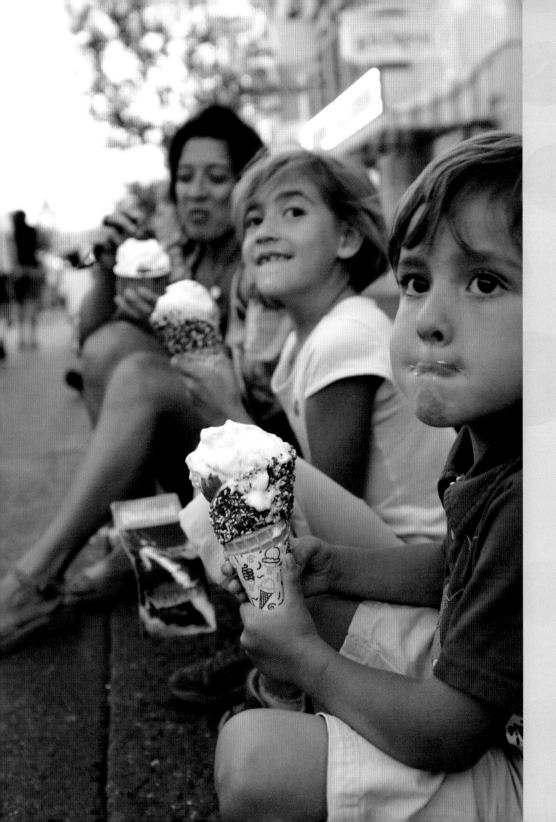

MY DSLR SETTINGS:
Aperture number was low at f/2.8. ISO was set to 200. Shutter speed was slower at 1/50 sec. (50).

45

bedtime rituals

Bedtime opens up the sweetest moments of connection for a family. The tween who struggles to find words for how she feels lets them flow when the lights are out. The unstoppable energy of the five-year-old, hanging on to every word in the story, is captured. Prayers are said; hugs and kisses are freely given. The bedroom door is cracked just right—to allow for enough light as the day's adventures finally come to an end and dreaming begins. Emily Cummings, an online student in my Magical Light course, used the least amount of light to capture the magic of bedtime.

WHEN: At bedtime, when your child is cozied up and captured by a favorite book.

PREP: Have child and parent sit comfortably in bed with a favorite book propped across their laps. Turn off the overhead light, but keep a bedside lamp on for a quiet ambiance or crack the bedroom door to use the light from the hallway.

FOR P&S USERS: Turn off the flash. Set the camera to Portrait mode to enable a low aperture number. Consider boosting the ISO to keep the shutter speed from getting too slow. You may need to use a tripod or brace yourself against a door frame to steady the shot if shutter speed gets too low.

FOR DSLR USERS: Turn off the flash. Select Aperture Priority mode, and dial down the f-stop to f/1.4 or your lowest setting. Bump up the ISO to keep the shutter speed in the range of 1/100 sec. to 1/200 sec. for sharpness. Consider manually setting white balance to prevent color casts from affecting the lighting. If color becomes a problem, consider black-and-white mode as well.

COMPOSE: Horizontal framing will capture your snuggly pair with enough of the surrounding bed to tell the story. But don't let them get stuck in the middle. Instead, use the Rule of Thirds to place them just off-center.

CAPTURE: Focus on your child's face. If it's not at center, reframe to center, lock focus and exposure, and then return to your original composition and fire. Try different angles and distances until you get the image you love.

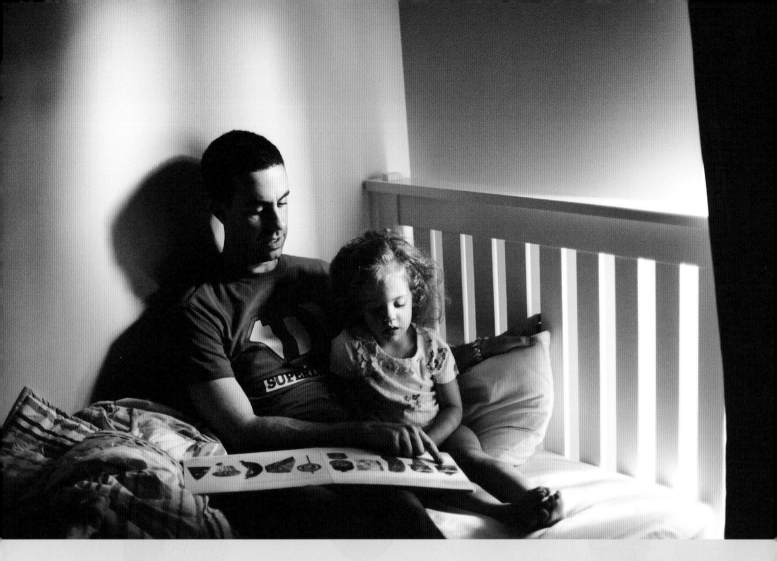

DSLR SETTINGS:
Aperture number was low
at f/1.4. ISO was set to 3200
because of dim lighting.
Shutter speed was 1/200
sec. (200). Photo by Emily
Cummings

Photo by Neyssa Lee

4

holidays

"Blessed *is the* season which engages *the* whole world *in a* conspiracy *of* love."

—HAMILTON WRIGHT MABIE

h olidays reach across cities, states, and even continents—gathering our loved ones from near and far to be together again. Day-to-day life is replaced with a certain magic in the air as we see the light of anticipation in our children's eyes. Children go to sleep with smiles on their faces, thinking and dreaming of what will be under the Christmas tree, while parents try to assemble the new bike before sunrise. Holidays allow us to pause, to renew our love, dress up in costumes, give thanks, and celebrate new life as kids stain their hands with Easter egg dyes. What better reasons are there to capture your family throughout the year!?

five tips
for photographing the holidays

1. **IDENTIFY THE THREE STORYTELLING ELEMENTS.** As I shared in my first two books, you want to "refuse to say cheese" and instead look for the three different storytelling elements when documenting your family. These are conflict, defining details, and a setting with a purpose. Holidays can cause us to overshoot because there is so much we want to hold on to, from family gatherings to holiday crafts. But when we overshoot, we often feel that much more overwhelmed when trying to pick favorites to print. Instead, save yourself from having hundreds of holiday photos to sort through by first identifying what the storytelling elements are and then shooting for those.

2. **DO THE POV DANCE.** People often find one place to stand and take all their photos without ever moving their feet. Think of shooting as more of a dance. As you look for your three storytelling elements, consider the different points of view for what you're shooting. Step back and go wide for the setting photos, but then get in close and tight when shooting defining details—and then repeat the dance all over again by getting up high or down low.

3. **MEET THE RESISTORS HALFWAY WITH A PLAN.** Every family has members who resist the group photo. Meet these resistors halfway by having a plan for the photos to happen at a specific time with a time limit to be grateful for their cooperation. When people see you being proactive and sensitive to their feelings, they're much more apt to cooperate.

4. **FIND INSPIRATION FROM MAGAZINES.** If you were photographing your holiday for a magazine feature, what types of photos would you want to show? Look to your favorite magazines for inspiration. Notice how the people are captured. Are they looking at the camera or engaged with one another? Notice how the details are photographed. Did the photographer get super close and fill the frame or stand far away? Building an awareness of what captures your eye in a favorite magazine will directly impact your own shooting.

5. **INCREASE YOUR ISO.** Especially with fall and winter holidays, you may find yourself frequently facing low-light situations. Before shooting, increase your ISO to 800, even 1600. This will let more light into your camera, helping you avoid the built-in camera flash or motion blur by giving you sharper, brighter photos.

valentine's day

Love is a commitment that asks everything of us. It is the glue that holds our family together. In the business of our lives, we often don't have time to pause and celebrate it. For this Valentine's Day, why not capture a photo that honors your relationship? You can do this with a tripod or the help of a friend. The key is to carve out time to do it, because these are the portraits that will be your family's testimony of love for generations to come.

WHEN: Late afternoon when beach light is golden with long shadows, about thirty minutes before full sunset. If you don't live near the ocean, you can capture this same romantic feel in a wide open scene, like a meadow or city park.

PREP: Find comfy clothes that you like to cuddle in, like a cozy sweater and jeans for him and something feminine and flowing for you. Think of materials that will reflect the sunset's light. Either enlist a friend or bring along a tripod to help capture the photo.

FOR P&S USERS: Turn off the flash. Set the camera to Portrait mode (or Sunset mode, if available). Set your camera to Continuous Shooting or Burst mode, if you have the option; this way, you can take several photos at once to capture your walk in midstep.

FOR DSLR USERS: Turn off the flash. Set your camera to Continuous Shooting or Burst mode so that the camera will take several frames per second. This way, you increase your odds of capturing a photo that shows your feet in midstep versus planted. You want the photo to show that you're walking. Select Manual mode. Since you're at the beach, you probably have plenty of light. See how low you can set your ISO. Choose a lower f-stop, like f/2.8, for a buttery blurred background. Have your spouse start walking as you finesse what your shutter speed should be. To freeze action, you want a shutter speed that is at least 1/125 sec. But as you can tell from my shutter speed, there was so much light on the beach that my shutter was moving as fast as 1/3200 sec. If you're using a tripod, set the self-timer or use a remote shutter release to trigger the picture-taking.

COMPOSE: Horizontal framing gets the couple and surrounding scene into the frame, with the waves falling in front of and behind the walking couple. Consider tilting the camera slightly to accentuate the feeling of movement.

CAPTURE: Focus on the middle of the couple, such as the contrast area where their arms are connected. If that's not centered in the frame, reframe to center, lock focus, and then return to the original composition and fire.

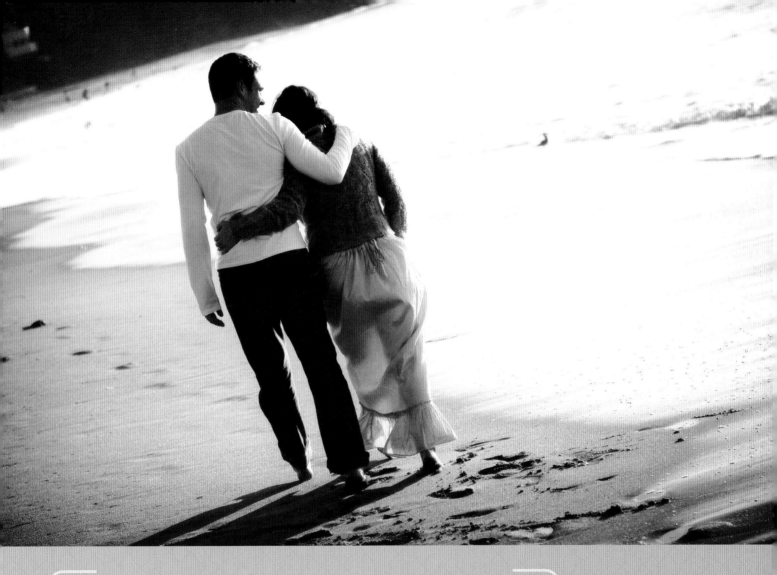

EMPHASIZE THE AFFECTION

Take turns looking at each other with a smile. Capturing one of your smiles in profile helps emphasize your affection for each other; if you're both looking straight ahead as you walk away from the camera, the photo's story feels colder and more disconnected. This simple trick changes the look and feel dramatically, and often elicits giggling because you feel silly doing it (which is all the better for capturing a genuine feeling of joy in your photo!).

MY DSLR SETTINGS: Aperture number was low at f/2.8. ISO was set to 200. Shutter speed was fast at 1/3200 sec. (3200).

easter

Easter brings with it the fun tradition of dyeing eggs. Little do children know that parents approach the activity with dread anticipating all that can go wrong when kids have bowls of dye at their disposal. And yet, it's one of the most fun activities to capture with your camera (maybe it's because the stakes are so high!). But due to all the potential messes, you may want to stay behind the camera and focus on capturing the kids. Or elicit extended family to join in the fun to make it more of a family portrait.

WHEN: Morning or afternoon, when kids are rested and ready to dye Easter eggs.

PREP: Why stress about the mess happening inside? Just take the whole activity outside! Have your egg-dyeing station all set up beforehand at an outdoor table that you can easily walk around for capturing different angles and views.

FOR P&S USERS: Turn off the flash. Set your camera to Portrait mode for more of a buttery blurred background.

FOR DSLR USERS: Turn off the flash. Select Aperture Priority mode, and choose a low aperture number, like f/2.8 or lower. Set your camera to Continuous Shooting or Burst mode to capture all the excitement on their faces.

COMPOSE: These photos can be done in either horizontal or vertical formats, depending on what you want your focus to be. An overhead horizontal shot gives you a bird's-eye view of the entire activity, while close-in shots focus on the details, like dye-stained hands and eggs being dipped. Play around with angles, tilts, and framing to capture a series that tells a story.

CAPTURE: Experiment with focusing on the activity rather than on your children's faces. This will accentuate the story's events even more. Pick your focus point (like their hands dipping eggs or when they show off their dye-colored fingers), and center it to lock focus; then return to your original composition and fire away.

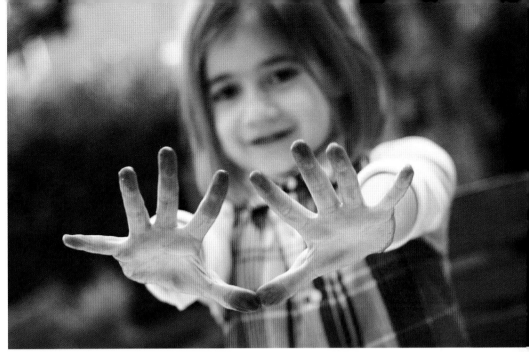
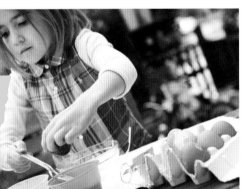

INCREASE THE BLUR

You can increase the blur in the background even more without having to change your f-stop. Simply move your body and camera closer to what you're focusing on, like dye-stained hands. The closer you are to what you're shooting, the blurrier the background will become. Notice how Pascaline's green hands are in focus, but her face is softer in the background without having changed the f-stop. Even though her smile isn't sharp, the emotion is almost more powerful.

MY DSLR SETTINGS:
Aperture number was low at f/2.8 to keep focus on the subjects. ISO was set to 100 under the bright outdoor light. Shutter speed was 1/100 sec. (100).

fourth of july

Firework shows are so much fun to photograph, but the fireworks are often so high in the sky that it's hard to capture a story that has your family in the photo, too. Enter sparklers and fountains! Playing with sparklers in the driveway can be the perfect setting for a family "fireworks" photo. Crystal Garcia, an avid blog reader in Bellingham, Washington, noticed the great lighting that the fountain of sparks was making. The porch light helped illuminate the kids, along with her husband shining his LED flashlight on them. But what makes this moment so precious is the clothes—look at the sweet red ruffles on that dress! Plan ahead this Fourth of July to capture your own darling family fireworks picture.

WHEN: Early evening on the Fourth of July, or any other festive fireworks occasion, when it's just dark enough to really see the fireworks.

PREP: Dress the kids in red, white, and blue to accentuate the Fourth of July look and feel. Then find a good vantage point ahead of time that will give you access to more sources of light, like a porch light or street lights. Set up to take the photo behind your children and the fireworks display. Consider having a friend or spouse on hand with a flashlight, as Crystal did, to help with additional light if you're struggling to grab a focus point.

FOR P&S USERS: Turn off the flash. Set your camera to Night or Night Portrait mode (many P&S cameras now have a Fireworks mode!). If the Night modes require flash, choose standard Portrait mode. You want to avoid the flash going off.

FOR DSLR USERS: Turn off the flash. Set your camera to Aperture Priority mode, and select your lowest setting, such as f/1.4 here. If you can't grab a focus because it's too dark, switch to manual focus or enable the autofocus assist setting.

COMPOSE: Vertical framing works best here, keeping focus on the connection between the children at the bottom while having the top third of the photo filled with the fireworks display. Get down low, and leave enough of the surrounding scene in the frame to help tell the story.

CAPTURE: Experiment with different focus points, such as your children's clasped hands or the back details of clothing. If shooting a single child, focus on the center of his body. Pick your focus point, and if it's not center of the frame, adjust your framing to center it and lock focus; then reframe to the original composition and shoot.

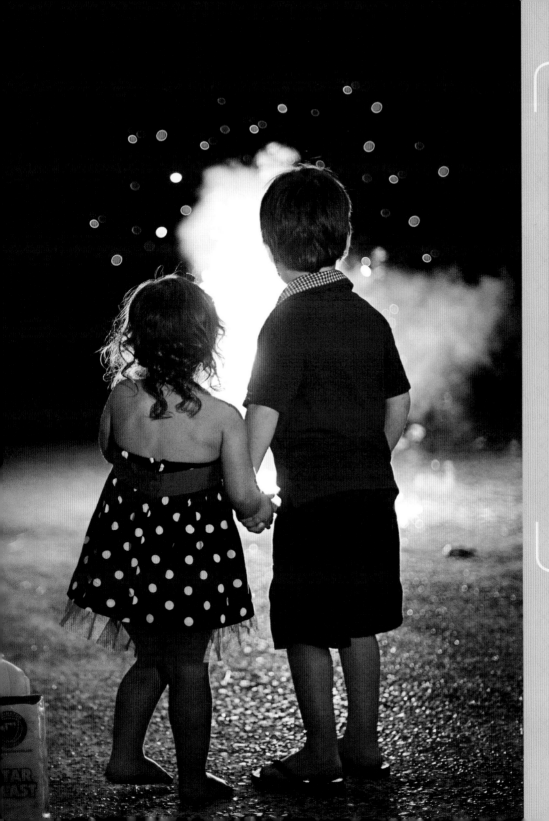

HOW TO CAPTURE FIREWORKS IN THE SKY

Ever wonder how to capture great fireworks photos? It's super simple! Visit http://tinyurl.com/capturefireworkswith-MERAKOH for my most popular photo recipe on how to capture fireworks in the sky. This photo recipe has been pinned hundreds of times, and the results readers share with me are so much fun! Be sure to share your own results on my Facebook page so that I can celebrate your photos, too!

DSLR SETTINGS: Aperture number was low at f/1.4 to blur the background. ISO was set to 600 to boost exposure. Shutter speed was 1/160 sec. (160). Photo by Crystal Garcia

halloween

The biggest mistake I ever made taking Halloween photos was waiting until Halloween night. By nightfall, the kids had one thing on their mind—and it was not posing for photos. But I also realized from the moment the kids got their costumes that they wanted to wear them all day, every day! I jumped on this enthusiasm by letting them put their costumes on early "if" they let Mom do a photo shoot, too. Amy Rhodes, a former CONFIDENCE workshop attendee in Nevada, ran into the same issues and shares her favorite trick below. I've heard many a parent comment about chasing kids down the street only to capture photos of their backsides running up to doors. How many of us can relate? This Halloween, start your picture-taking ahead of time for the best results.

WHEN: A week or two before Halloween—or earlier on the day of, preferably late afternoon when the bright daylight has diminished.

PREP: If you live on a quiet neighborhood street with low traffic, find a safe spot (like a cul de sac) where you can use the dark asphalt to fill the background. If there isn't a safe street option, find a clear expanse of concrete (like a sidewalk, patio, or driveway). You can even use an old advertising trick and wet down the surface beforehand for that slight reflective glisten. Have your child play around with posing that goes along with the costume.

FOR P&S USERS: Turn off the flash. Set your camera to Portrait mode to enable lower aperture numbers and a blurred background.

FOR DSLR USERS: Turn off the flash. Set your camera to Aperture Priority mode, and select an aperture of f/2.8 (or however wide open your lens is able to go). After taking a few photos, make sure your shutter speed is above 1/125 sec. (125) to ensure there isn't motion blur or camera shake if the kids or your hands move. If your shutter speed is below this, increase the ISO to allow for more light and a faster shutter speed.

COMPOSE: A vertical format will fill the frame with your child's full length of costume. Get down almost to your child's eye level, looking down slightly, and play around with angles and tilts, as in the werewolf shot. Then get in close to pick up costume details.

CAPTURE: Focus on your child's face. If your child's face isn't centered in the frame, reframe to center it, and lock focus. Return to your original composition and fire.

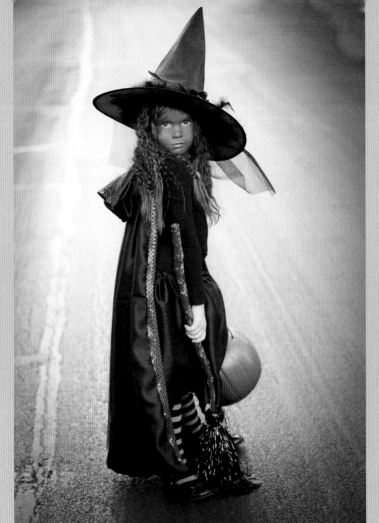

MAGICAL LIGHT WITH ASPHALT

Who would ever guess that asphalt could provide the perfect gray tones to bounce a beautiful light onto your subject's face? In fact, when doing family shoots, I often pick asphalt over grass at the park, because the bounce of light is soft and flattering where grass tends to suck up the light and bounce back green hues.

DSLR SETTINGS:
Aperture number was low at f/2.8 to soften the background. ISO was set to 500 to maximize the fading light. Shutter speed was 1/250 sec. (250). Photos by Amy Rhodes

 http://tinyurl.com/disneyjrMERAhalloweentips

thanksgiving

Thanksgiving is my favorite holiday. My youngest brother and I usually join up to cook for everyone, and every year I look forward to all the laughter that comes with it. Over the years, we have taken the family picture of everyone standing around the cooked turkey. But honestly, I would never print or frame those. Instead, I want to capture family pictures that represent the camaraderie of rekindled childhood stories, the warmth in the air, and the flurry of prepping (and yummy taste-testing) in the kitchen.

WHEN: During holiday meal prep or other activities, when everyone is enjoying one another's company.

PREP: Before the holiday arrives, reflect on what actions you love the most. Is it the table-setting, cooking together, working on puzzles, lounging on the couch as your family watches the football game, or maybe a traditional toast? Prepare to take family pictures that best represent the stories you love most about Thanksgiving. Find a vantage point where you won't be in the way, such as the other side of a kitchen island or a doorway looking in.

FOR P&S USERS: Turn off the flash. Set your camera to Portrait mode, which will let you focus on the subjects and give the background a slight blur. Play around with the Auto and Incandescent white balance settings to see which one delivers better color. Consider converting to black-and-white mode if the color cast is too warm or red in either setting.

FOR DSLR USERS: Turn off the flash. Put the camera into Aperture Priority mode, and choose a lower aperture number, like f/1.8 or f/2, to blur background details slightly. Raise your ISO for possible low lighting from being indoors in the evening. Set your camera to Continuous Shooting or Burst mode to increase your chances of capturing as many expressions as you can.

COMPOSE: For this shot, horizontal framing gets both family members as well as their cooking tasks in the frame, showing action. Stay at eye level so that the viewer feels like part of the scene. You can also add a little camera tilt to accentuate the motion of the moment.

CAPTURE: Focus on the face closest to you. If that's not in the center of the frame, reframe to center it, and lock focus; then return to your original composition and shoot.

WORKING WITH WHITE BALANCE INDOORS

Shooting indoors in the evening can be tricky with white balance. Try both Auto and Incandescent white balance settings to see how your color looks, or consider manually setting the white balance for the most accurate color balance, and take a few test photos. Alternatively, consider converting the image to black and white if color casts are too strong or not to your liking.

DSLR SETTINGS: Aperture number was low at f/1.8 to keep focus on the subjects. ISO was set to 1600 to boost the indoor incandescent lighting. Shutter speed was 1/250 sec. (250). Photo by Brian Tausend

christmas

Christmas is a season full of magic and wonder. Every night as you tuck the kids into bed, their anticipation grows more and more for Christmas morning. You can take the family portrait of everyone standing in front of the Christmas tree, but why not capture a story that speaks of the magic and wonder? This photo recipe is all about documenting that cozy, dreamy memory of kids in pj's with all the lights turned off and the tree lights twinkling before them. Lisa Walker, an avid blog reader in California, saw this moment happen with her daughter and dog and knew this was one of her most cherished memories of Christmas.

WHEN: Wait until after sunset, when the Christmas tree is the only light source and there's no daylight streaming into the house.

PREP: Set up a camera on a tripod or find a stable surface you can use to steady the camera, like a table or the arm of a chair or couch. Turn off all household lighting except for the tree. Have family get their pj's on to add more to the photo's story. Have taller subjects kneel down facing the tree and smaller children stand or reach up toward an ornament. But encourage them to be as still as possible to prevent blurring from the slow shutter speed.

FOR P&S USERS: Turn off the flash. If your camera has a Night Portrait mode that lets you disable the flash, select it. Otherwise, select Portrait mode for the lowest aperture.

FOR DSLR USERS: Turn off the flash. Turn on Spot Metering. Select Manual mode, and choose a lower aperture number, like f/2. Boost the ISO to 800 or higher until you get a shutter speed in the range of 1/50 sec. (50) to 1/60 sec. (60). Anything slower will run the risk of a blurry subject. Take a few test shots, and play around with your ISO settings until you get the exposure you like with the least amount of noise, or grain. Consider adjusting your white balance manually as well, depending on the color cast you'd like to get from the tree lighting.

COMPOSE: Due to the height of the tree, a vertical format will work best here. Frame your family so that they occupy the bottom two-thirds of the scene, leaving a small amount of the foreground in to help set the scene. Play around with angles and profiles until you get the composition you like.

CAPTURE: Focus on your child or the child closest to the center of the frame. If no one is in the center, reframe to lock focus and exposure, and then return to your original composition and fire.

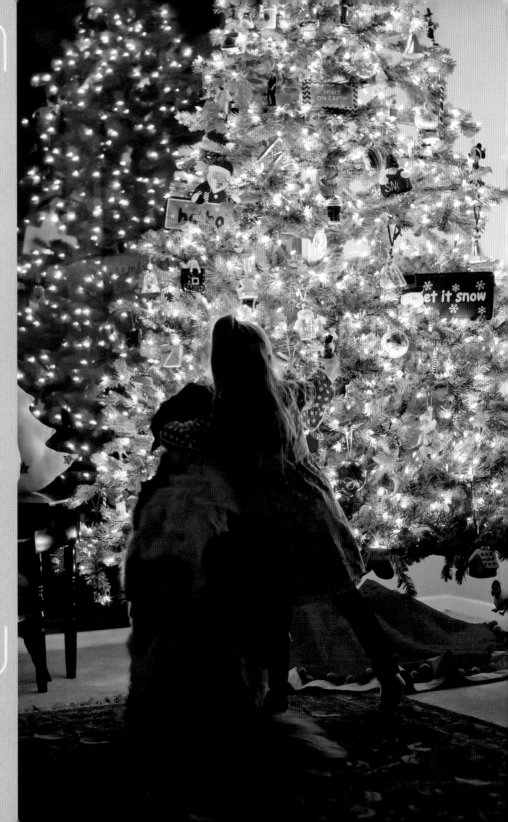

DEALING WITH LOW LIGHTING

If you're taking photos at night without a flash, you'll need a high ISO to get enough light. The only drawback to a high ISO is the potential noise (or graininess) that results. This is one reason to upgrade to a camera body above the $800 price range. The more expensive DSLRs can capture high-ISO images with almost no hint of grain. Another option is to invest in a tripod so that you can shoot with a lower ISO and leave your shutter open longer to allow more light to hit the camera sensor (but the kids have to hold superstill to prevent being blurred). Either one of these investments is better than using your camera's built-in flash. The flash will take away all chances of capturing ambient, cozy lighting in your photo.

DSLR SETTINGS: Aperture number was low at f/2.5. ISO was set to 1600 because of the low lighting, and shutter speed was slow at 1/50 sec. (50). Photo by Lisa Walker

birthdays

Birthdays are the best! The moment one birthday is over, the family is already brainstorming ideas for the next one. The birthday seems like it will never arrive, and then before you know it, the lights are being turned out and everyone is singing "Happy Birthday." You rush to grab the camera and end up with a photo that isn't worth writing home about. Let's change all that with the inspiration of this photo by Janna King, a former CONFIDENCE workshop attendee in Texas, and a photo recipe that will give you the best candle-blowing, birthday-singing results ever!

WHEN: On your child's birthday at the big moment of blowing out the candles.

PREP: Set the scene first. Consider how you can fill the frame with as many birthday details as possible. Set the balloon bouquet on the floor to add more depth and color to the background. Put the party cups and plates near the cake. Hang a sign in the background to offset a white wall. Have your white balance and exposure settings figured out beforehand so that you're ready when the moment comes.

FOR P&S USERS: Turn off the flash. Set the camera to Portrait mode for a low aperture number. Some point-and-shoot cameras even have a Birthday icon for this moment. Don't be afraid to crank up the ISO a little, as Janna did here, to 1000. Experiment with white balance settings to find the color balance you like most. Candlelight is warm and sometimes orange, so you'll want to try Auto, Manual, and Incandescent settings if available.

FOR DSLR USERS: Turn off the flash. Select Aperture Priority mode, and dial down the f-stop as low as possible to blur background details and let in more light. Boost the ISO until your photo is bright enough, and don't be afraid to go as high as 1000 or 1250. Try different white balance settings to find the color that looks most natural. If color casts become an issue, consider switching to black-and-white mode. Set your camera to Continuous Shooting mode so that you can capture the whole sequence of blowing out the candles.

COMPOSE: Get everyone set up around the birthday child, and have them leaning in with their faces toward the candles so that you can see all the expressions. Depending on the number of children around the birthday child, either a vertical or a horizontal format can work. In this shot, horizontal framing gives you more of the background party details and gets children in the background. If children are closer in and different heights, a vertical composition may be better. Have fun experimenting with both. Get down to your child's height so that the camera is looking straight into the scene.

CAPTURE: Focus on the birthday child. If necessary, reframe the image to center your child, lock focus and exposure, and then reframe to the composition you like and fire.

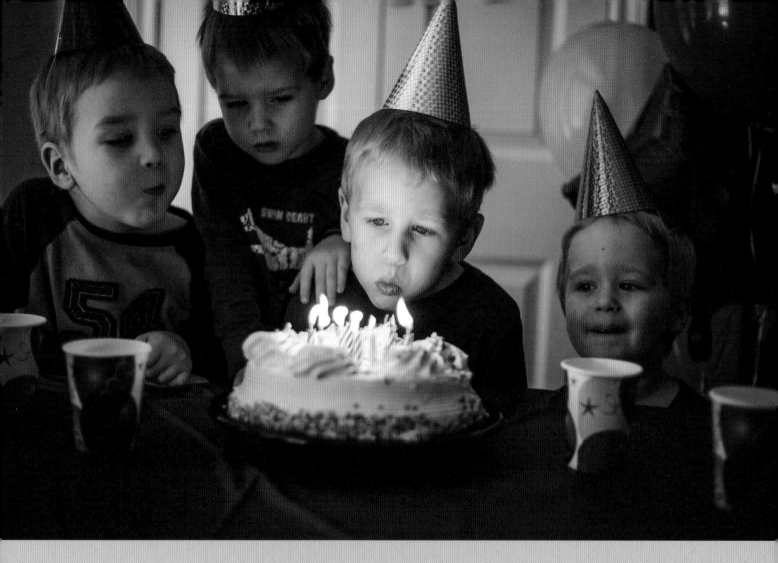

NEED MORE LIGHT

Since the birthday candles are your main source of light for this photo, if you don't have enough light, take Janna's great tip of adding more candles on the cake! Since you are shooting straight on, the actual amount of candles will be hidden (unless your little one is three or under). If you need to, relight the candles to do it again!

DSLR SETTINGS:
Aperture number was low at f/1.8. ISO was set to 1000 to boost exposure. Shutter speed was 1/160 sec. (160). Photo by Janna King

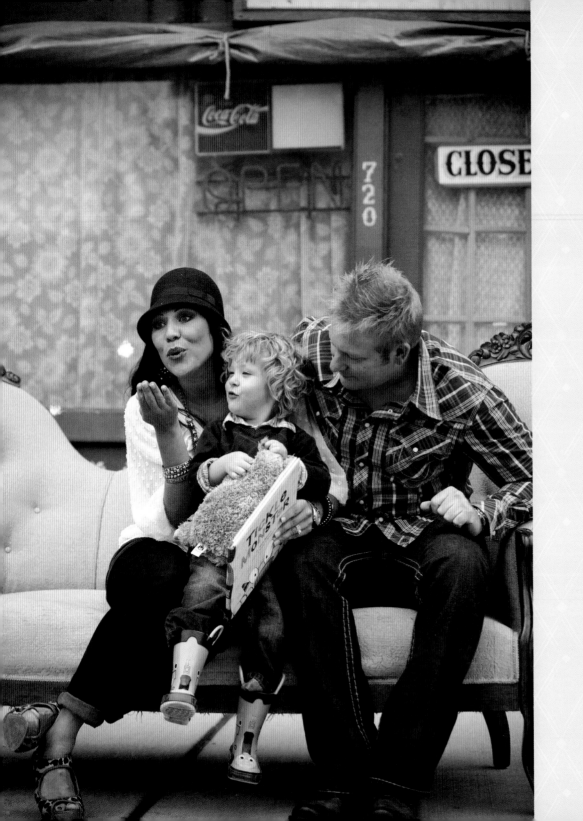

family
portraits

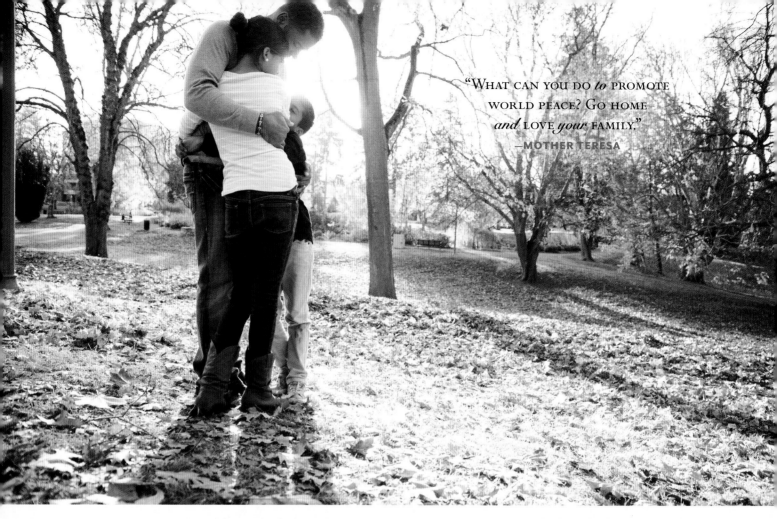

"WHAT CAN YOU DO *to* PROMOTE WORLD PEACE? GO HOME *and* LOVE *your* FAMILY."
—MOTHER TERESA

g one are the days of going to a professional studio, dressed in your best, to pose for the family portrait. With the growing noise in our lives from social media to the never-ending demands of raising a family, we long for family photos that are authentic and capture our true nature. Instead of having a single, framed family portrait on the wall, we desire to chronicle the many different seasons we experience, from the stages of motherhood to the annual visit from the cousins and grandparents. The value in a family portrait is no longer based on the print size but weighed by the emotion and connection we see and feel. These are the images we will look back on when the day feels lonely or life is moving too fast. These are family portraits that are not about a display of perfection but about a genuine connectedness from beautiful bonds that are not easily broken.

five tips
for photographing family portraits

1 MOM'S OUTFIT SETS THE TONE. The most common question I'm asked before doing a family shoot is "What should we wear?" I tell all my families the same thing. Have Mom wear what she feels most beautiful in, and everyone else's clothes should complement hers. (Because if Mom's not happy with the family portrait, nobody is.)

2 ALLOW FOR TIME AND SPACE. Over the years, I've noticed that families will allow very little time and space for capturing their family portrait. Maybe it's because most of us fear being in front of a camera, and the sooner we get it done, the better. But feeling rushed will almost always sabotage the whole experience. Allow for extra time and space, and everything will go that much more smoothly.

3 START WITH THE OBVIOUS (TO GET TO THE CREATIVE). You may want your family portrait to be more relaxed versus traditional, but start with everyone looking at the camera and smiling. This is what kids expect to do, and these are the photos grandparents love most. Plus, when you start with the obvious, there's less pressure to be creative, which lets the fun, untraditional ideas flow more easily.

4 SLIMMING LOOK MEANS NO HIDING. For a more flattering, slimming look, make sure the adults are standing at an angle to the camera. Resist hiding your body behind the kids, because this only makes you look bigger. Instead, have them stand to your side in front of half your body to add a more slimming line.

5 PREP THE FAMILY. Unless your children are preschool or younger, prep everyone the night before that you'd like to take a family portrait. This helps your spouse and kids mentally prepare and get on board versus feeling pulled from their own plans.

self-portrait of mom

As a mom and photographer, I've been acutely aware of how often I'm not in the photos because I am always taking the photos. But I don't want the generations after me to simply hear the stories of who I was. I want my loved ones to see the photos that document the chapters of my story: the milestones I reached, the journey I've walked as I discovered my confidence and love for myself, the mysteries and hardships I pushed through to experience victory and freedom. Self-portraits have become a way to chronicle my journey as a mom and woman. I started taking self-portraits in order to experience how awkward it is for my clients to be in front of the camera. What I discovered was a wonderful opportunity to document the stages of life that I found myself walking through. This practice acknowledges who I am now and shows me we are always evolving. I now have my CONFIDENCE teachers and students do this practice, too. These are their beautiful, powerful results to inspire you.

WHEN: During Mom's alone time, when kids are away at school or off with Dad, when you can quiet yourself and have space and time to create. If going outside, consider the early hour of sunrise or late afternoon for the most ideal lighting.

PREP: Find a location that is somewhat private and feels safe, calming. Maybe it's near a bright window in your home. Or, enlist a friend to help and find an open space like a nearby field or park. Set up the camera on a tripod or other stable surface, and preset your exposure settings.

FOR P&S USERS: Turn off the flash. Select Portrait mode for a low aperture number, and enable the self-timer.

FOR DSLR USERS: Turn off the flash. Select Aperture Priority mode, and choose a low aperture number, like f/1.4 or f/2, for a buttery blurry background that draws all our attention to you. Turn on the self-timer.

COMPOSE: Depending on your activity or pose, choose horizontal or vertical framing. If your self-portrait involves you doing an activity, like yoga, consider the pose to know what composition would best tell the story. If the photo's story is meant to convey a quiet feel, consider a horizontal frame that allows room for empty space. Allow yourself to play around with different ideas to find the composition that best captures your self-portrait.

CAPTURE: Find a point in the center of your composition and lock focus. If you have to, shift the camera to center the area of focus, lock, and reframe to the original composition. Press the shutter button, and quickly get into place before the shutter fires.

BEGIN WITH REFLECTION

The key to taking a successful self-portrait starts before you even pick up the camera. Create space to first spend time reflecting on the current season of life that you are in. If you're not one to journal, here are a few writing prompts that will help jog your thought process on what story you want to tell in your self-portrait.

1. Write down three emotions that come to mind when you think of this time in your life.
2. Write down one or two activities that best represent the woman you are.
3. Think of one or two objects that represent current passions or hobbies. Write a few sentences about why they do.

Taking time to process and reflect before pulling out the camera will make all the difference in helping you capture what you envision.

See **http://tinyurl.com/disneyjrMomphotoMERA1** and **http://tinyurl.com/disneyjrMomphotoMERA2** for two different episodes of Me Ra walking moms through the rewarding process of capturing their self-portraits.

Top: Photo by Allison Gallagher f/11 for 1/10 sec., ISO 500
Bottom: Photo by Nicole Elliott f/4.0 for 1/60 sec., ISO 400

Photo by Tina Erdman f/1.8 for 1/320 sec., ISO 100.

Photo by Neyssa Lee f/2.8 for 1/250 sec., ISO 2000.

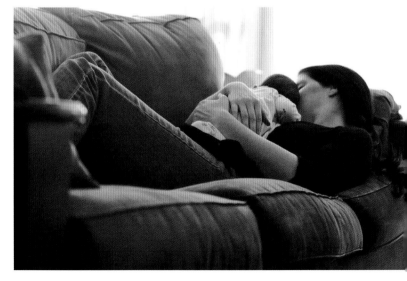

Photo by Jennifer Leigh f/2.8 for 1/80 sec., ISO 400.

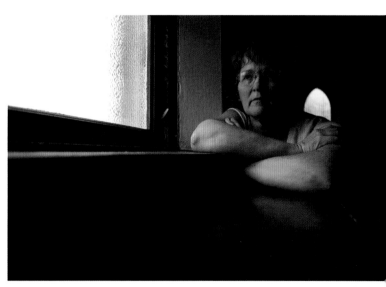

Photo by Nikki McLaughlin f/2.8 for 1/1600 sec., ISO 200.

Photo by Laura Swift f/2.8 for 1/640 sec., ISO 400.

Photo by Lynda Kennedy f/2.2 for 1/50 sec., ISO 640.

Photo by Me Ra Koh f/2.8 for 1/200 sec., ISO 100.

Photo by Summie Roach f/2.8, shutter speed 1/100 sec., ISO 125.

portrait of dad

One of the greatest joys in my marriage has been the front-row seat I've had to witness the incredible transformation of my husband. We will have been married for almost twenty years, and I am in awe at how he is ever evolving into the man he is meant to be. From the twenty-four-year-old newlywed who installed telephone systems to the cinematographer he is now, his changing portraits throughout our family life are what I dream our future grandkids finding courage from.

WHEN: Find a time when Dad is enjoying a favorite activity or visiting a favorite location. Plan ahead so that you have magical light from either a sunrise or sunset.

PREP: Have Dad wear or bring an object with him that is symbolic of this current season in life. Experiment with having him sit or pose where he's most comfortable. Find a good spot that has lots of room around you both to play around with angles and creative framing.

FOR P&S USERS: Turn off the flash. Select Aperture Priority mode for a blurred background. Consider enabling any fun picture effects, such as Vivid mode or special scene modes like Sunset.

FOR DSLR USERS: Turn off the flash. Select Aperture Priority mode, and choose a lower aperture number, like f/2.8. If there's a lot of sky in the composition, select Spot Metering mode to lock exposure on Dad.

COMPOSE: Choose either horizontal or vertical framing, depending on the activity or setting. A horizontal setup works well here because it gets a lot of the sky in the frame, with Dad in the lower portion looking up, setting the scene. The story of him being a dreamer is accentuated by him looking into the sky. Play with camera tilts and angles to add interest or motion to Dad's story.

CAPTURE: Focus on Dad. If he's not in the center of the frame, reframe to center him, and lock focus and exposure; then return to the original composition and shoot.

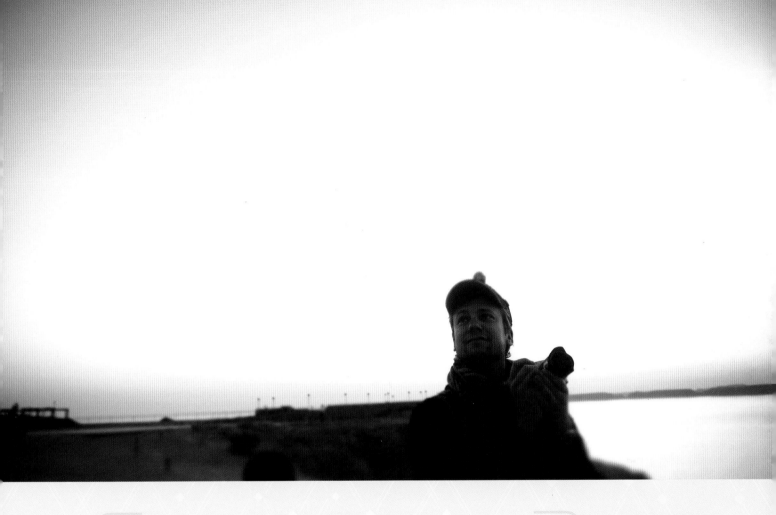

INCREASING THE DRAMA

Most point-and-shoot cameras now have fun picture effect modes to experiment with. It's like a luxury version of Instagram, except you have higher megapixels for better print quality. One of my favorite picture effects is when you can accentuate the blur in two of the thirds (top, middle, or bottom) to add a dreamier effect. This not only increases the drama but expands my own fun and creativity.

MY DSLR SETTINGS:
Aperture number was low at f/2.8, and ISO was set to 800 to maximize sunrise lighting. Shutter speed was 1/250 sec. (250).

you and your spouse

When was the last time the two of you had your picture taken or put effort into having a portrait done? Most couples answer, "Our wedding day." If you answered the same, all the more reason to be intentional about capturing a portrait of your love for each other. We often take these portraits with our smartphone held out in front of us, but carve out a little time to take this family photo to the next level. After all, you are both where the family began.

WHEN: During a date night or any time it's just the two of you enjoying each other's company.

PREP: If either of you are feeling anxious beforehand, start with a glass of wine to ease your nerves and any tension. Then find a location that will give you some privacy, like a stairwell, downtown alleyway, or nearby field. This way you don't feel as rushed. You can also each think of funny things to say when the camera is ready to fire—to help prompt genuine smiles and laughter. Set up your camera on a tripod, or find a sturdy, level surface to set the camera on. Get your exposure and focus before enabling the self-timer.

FOR P&S USERS: Turn off the flash. Select Portrait mode to blur the background details. Activate the self-timer.

FOR DSLR USERS: Turn off the flash. Select Aperture Priority mode, and choose a low aperture number, like f/2.8. Take a few test shots to see if your settings need to be finessed in Manual mode. Set your camera to Continuous Shooting mode to allow rapid-fire exposures. Enable the self-timer.

COMPOSE: A horizontal format will get both of you in the frame and is best for close-ups like this. In this photo, the camera is tilted slightly to add a sense of movement. Though the man's head is cut off slightly, we get a close, intimate pose that draws focus to their facial expressions. Hands also communicate affection and adoration, so try to keep them relaxed and close to each other. Make sure that your shoulder is in front of his and that you are leaning into him for a more slimming, flattering photo result.

CAPTURE: Focus on the face closest to center; then reframe the shot and fire the shutter. (But honestly, if he is in focus and you aren't, the photo will probably never see the light of day. So focus on you. And smile!)

MY DSLR SETTINGS:
Aperture was set to f/2.8 to soften the stairs. ISO was set to 100, and shutter speed was 1/320 sec. (320).

sisters

The bond of sisters is like no other. Growing up, sisters share secrets, clothes, and daily fights over the bathroom. When you aren't best friends, you may be each other's worst enemy. And yet, no one else "gets you" like your sister. No matter how much you got under each other's skin, you still look out for each other, snuggled when one of you woke with bad dreams, and defended each other against any bully that posed a threat. You would do anything for your sister. Your similarities are undeniable, and now your love for the other's differences is beautiful. Kelli Kalish, a former CONFIDENCE workshop attendee in Illinois, captured the timeless, simple beauty of sisters.

WHEN: Morning or late afternoon, when your children are enjoying one another's company and the light isn't overly bright and harsh. (Overcast days are ideal.)

PREP: This is a casual portrait, focusing on the children and their relationship, so choose a background outdoors such as trees or open field, that isn't too distracting. The overcast sky prevents harsh shadows and provides even, diffused lighting. For black-and-white photos, consider having the kids in white T-shirts or tanks to contrast their skin against the background for a soft look.

FOR P&S USERS: Turn off your flash. Select Portrait mode for a buttery blurred background. Consider using Continuous Shooting mode if there are younger siblings who move around a lot.

FOR DSLR USERS: Turn off your flash. Select Aperture Priority mode, and set your aperture to f/2.8 or f/3.5 to blur the background and focus on faces. Consider switching to black-and-white mode, as the combination of a blurred background and monochrome photo will help keep focus on the children versus any background elements. (It also downplays any wardrobe issues if your children aren't in solid colors as they are here.)

COMPOSE: A horizontal format works well with two or more, filling most of the frame with your children's faces. Frame faces in the top third of the image area. To achieve the more serious look here, have your kids close their eyes and think about relaxing their eyes and mouth. Then on the count of three have them look right into the camera.

CAPTURE: To make sure everyone's face is in focus, I tell kids to imagine that their noses all have to touch the same glass wall. This helps you get both bodies and heads within the same plane of focus. Focus on the center face if shooting an odd number of children. If shooting two or four children, focus on the face closest to the center; then reframe to the original composition and shoot.

DSLR SETTINGS: Aperture was f/3.5 to make sure each girl was in focus, since multiple subjects are often not all the same distance from the camera. Outdoor lighting was bright and diffused, so Kelli set the ISO to 200. Shutter speed was a quick 1/200 sec. (200). Photo by Kelli Kalish

brothers

Capturing images of children can be difficult, especially when the subjects are rascally, wild brothers! Sometimes everything you do to try to get them to hold still or pay attention just fails. When that happens, my advice is to go with the flow and capture their natural interaction. I love how Allison Gallagher, a former CONFIDENCE workshop attendee in Virginia, shared that she stopped fighting the boys' energy and took it up a notch by encouraging them to take turns making each other laugh. Before they knew it, everyone was laughing, and the photos were a success!

WHEN: Morning or late afternoon, when the sun isn't directly overhead and shadows are soft. Find a time when siblings are in the mood to play around for the camera (and have eaten within the last thirty minutes—you know kids!).

PREP: Find a spot outdoors, such as front porch steps, doorways, or another somewhat contained area where boys can sit next to each other without too much space for wrestling.

FOR P&S USERS: Turn off the flash. Select Portrait mode for blur in the background. But if your photos are blurry, try Sports mode for faster shutter speeds if your camera offers it. Consider using Continuous Shooting mode for rapid fire so as to not miss a shot.

FOR DSLR USERS: Turn off the flash. Select Aperture Priority mode, but have your f-stop a little higher than normal, like f/4.0. This will help ensure your children are in focus with all the moving around they may be doing. If your photos are blurry, check your shutter speed. You want the shutter speed to be around 1/250 sec. (250) to freeze their movements. If it's lower than that, switch to Manual mode and raise your ISO so that you can have a faster shutter speed. Choose Continuous Shooting mode so that you can capture multiple exposures quickly and not miss an expression. To help keep focus on faces, consider black-and-white mode if your background is too distracting.

COMPOSE: A horizontal format works best for multiple subjects. Get in close and stay at around your subjects' eye level.

CAPTURE: Since your subjects will be on about the same focal plane, focus on the child closest to the center of the frame. If he's not directly centered, reframe to center, and lock focus; then reframe to your original composition and fire.

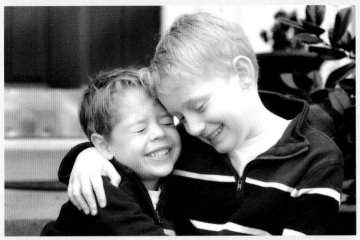
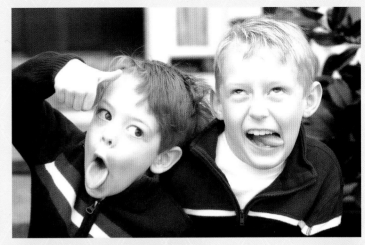
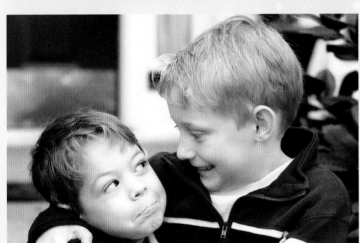

THE EASIEST WAY TO DEAL WITH WIGGLES

When the boys are squirming and wiggling like they have ants in their pants, the easiest way to deal with it is to have them sit their bottoms down. (Did I sound authoritative with those last four words? Can you tell I've said them often?) You may not get them to calm completely down, but having wiggly kids sit on the ground or floor does away with at least half of their energy.

DSLR SETTINGS:
Aperture number was low, at f/2.8, to soften the background and keep focus on the brothers. ISO was set to 400. Shutter speed was 1/250 sec. (250). Photos by Allison Gallagher

cousins

When I was growing up, my cousins would come over all the time. From infants to eight-year-old, we were a force to be reckoned with. The trouble that my brothers got into with our cousins produced some of the funniest stories we share when we are all together. And rounding us up for a photo was like asking for a miracle. That's why I love what Nicole Elliott, a former CONFIDENCE workshop attendee in North Dakota, did to capture her nieces and nephews. How do you get that many squirrely kids to be still for a photo? You have them sit their bottoms down! That is the secret!

WHEN: Any time you have a group of cousins together, after the initial excitement of seeing one another has died down and you can get them to sit relatively still and together. Look for morning or afternoon light or an overcast day for even lighting.

PREP: Have cousins line up on a sidewalk (as shown) leading off into greenery. Line them up as close as possible. Have babies waiting in the wings with Mom for last-minute placement in the composition.

FOR P&S USERS: Turn off the flash. Set your camera to Portrait mode for a nice blurry background. Consider using Continuous Shooting mode so that you can rapid-fire and not miss an expression.

FOR DSLR USERS: Turn off the flash. Set the camera to Aperture Priority mode, and choose a low aperture number (f/2.8 or lower) to get a soft background and keep focus on your subjects. Use Continuous Shooting mode, especially if younger kids are involved.

COMPOSE: Horizontal framing works best with a line of children like this. Use the Rule of Thirds to position the foreground (concrete), the kids, and background. Get down low and keep kids in a line so that they're all in the same plane of focus.

CAPTURE: Focus on the face closest to the center of the image. Since all kids should be in the same plane of focus, this should keep all faces sharp. If you need to, reframe your shot to lock focus on the central child, and then go back to the original composition and fire.

LET GO OF PERFECTION

A successful photo of cousins ranging from ages six months to six years isn't about capturing perfect little smiles. It's about capturing all the rambunctious energy in the kids as they try to make the younger ones smile by squishing their faces. Not every face may be looking at the camera, but the overall story—that allows for a little bit of chaos—is the family picture that you will all adore when they are grown and have kids of their own.

DSLR SETTINGS:
Aperture number was low at f/2.8 to get a buttery background. ISO was set to 200 because of all the available light, which leads to the best color saturation. Shutter speed was 1/600 sec. (600). Photo by Nicole Elliott

grandparents

Grandparents are the tenderness of a family, a special treasure in childhood. With gentle eyes and patient hearts, they love unconditionally—always ready with a hug or a listening ear. Their stories hold irreplaceable wisdom spanning generations. Yet for a number of reasons, grandparents often shy away from the camera. Consider documenting the bond between grandparent and grandchild and the contrast in age without everyone looking at the camera, whether it's walking away from the camera, hand in hand, or in details like the ones captured so beautifully here by Veronica Bernal, a former CONFIDENCE workshop attendee in Texas. Getting in close tells the story of the rough, well-worn working hands of grandpa embracing the new, smooth, small hands of your little one.

WHEN: During a family gathering, when everyone is comfortable and relaxed. Moments when young ones are also engaged in cuddling with the grandparents. If shooting outdoors, try for morning or afternoon light. If shooting indoors, plan for a time of day when window light is strong.

PREP: Look for window light that allows for softer results. If there isn't a bright enough window in the home, try stepping outside or into an open door frame. The framing is so close that the background won't make a difference. Your biggest priority for prepping is finding enough light.

FOR P&S USERS: Turn off your flash. Select Portrait mode for a low aperture and shallow depth of field, keeping your focus on the hands. Consider switching to black-and-white mode if clothing colors or patterns become too distracting.

FOR DSLR USERS: Turn off your flash. Select Aperture Priority mode, and set the f-stop to f/2 or your lowest aperture number. Get in close, or use a zoom lens if you want to keep a physical distance and not interrupt their connection.

COMPOSE: For this image, a horizontal format perfectly frames the hands embracing. Get in close so that the majority of the image is the embrace itself. Think about framing just a small part of your child's face, as Veronica did here.

CAPTURE: Focus on the hands closest to center. If your child's hands are slightly above center, reframe to center them, and lock focus; then return to your composition and shoot.

LESS IS MORE

The old, tried-and-true advice for writing is a powerful tool for photography too: less is more. When shooting details like hands, zoom in or move your body so close that there is nothing else in the frame except for that detail. If the background isn't adding to the overall story, there's no reason to have it in the photo. This may feel awkward if you aren't used to it, but it's a wonderful creative exercise to ask yourself, "How much tighter can I get? What does 'less is more' look like for the story I'm capturing?" The clearer the photo's story, the more powerful it is.

DSLR SETTINGS:
Aperture number was moderately low at f/2.4. ISO was set to 100 with ample light. Shutter speed was 1/200 sec. (200). Photo by Veronica Bernal

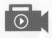 http:/tinyurl.com/grandparentsMERA

pets

Our pets are some of the family's funniest and most loving characters. Their personalities shine through the chaos of day-to-day life. Whether your dog is always happy to see you or your cat acts like he couldn't care less, their personalities bring daily humor to your family. Why not set out to take a purposeful portrait in which your pets are the spotlight but the sense of family still surrounds them. I love how Jess Roberston, a former CONFIDENCE workshop attendee in California, did this perfectly by framing the photo so that we don't see Mom and Dad's faces—and yet they are still a part of the overall family pet portrait.

WHEN: Any time your family pet is relaxed and happy to sit or lie down, perhaps after a walk or play session when he's ready for a break. Try to find a time in the morning or afternoon when the sun isn't overhead and shadows are soft.

PREP: Choose a location with few distractions, both compositionally and for your pet, preferably with a bench or short wall for the family to sit on. Have your composition and settings ready to go before corralling the pet so that you don't miss an opportunity. Consider having treats on hand, and possibly a child or another person behind you to help capture the animal's attention.

FOR P&S USERS: Turn off your flash. Set your camera to Portrait mode to blur the background slightly. Consider using Continuous Shooting mode if your pet can't sit still.

FOR DSLR USERS: Turn off the flash. Set your camera to Aperture Priority, and choose a low aperture number, f/4 or lower, to blur the background details slightly. Consider using Continuous Shooting mode to freeze movement.

COMPOSE: Horizontal framing works well here, getting the pet in the foreground and the family members in a line behind. Frame the pet just off-center to the right or left, with the family's knees and feet in the shot. Shooting at an angle like this, rather than dead center, uses the lines in the brick, bench, and sidewalk to pull the eye in toward the dog.

CAPTURE: Focus on the pet's face. If it's not centered in your composition, reframe the image to center, and then lock focus and fire.

HOW TO PHOTOGRAPH ACTIVE PETS

If you have an active pet, you want to do two things: First, take it to the park to run off some of that high energy. Second, look for small places to take the photos, like doorways, bunk beds, and stairwells. The smaller the space, the calmer your pet's energy will become.

DSLR SETTINGS:
Aperture was set to f/4.5 to keep background textures in focus. ISO was set to 500 because of the cloudy day. Shutter speed was 1/125 sec. (125). Photo by Jess Robertson

 http://disney.go.com/disneyjunior/nightlight/merakoh

the family portrait

Even though I love to document "refuse to say cheese" moments, I also love the annual family portrait. It's a wonderful way to see how much the kids have grown in the last year. Plus, while the twenty- to fortysomethings love the unposed portraits, clients confirm every year that grandparents still appreciate seeing every last grandchild's smile looking right at the camera. I also invite you to look at the different examples and contributions from me and my CONFIDENCE teachers and students for even more inspiration for this year's perfect family portrait!

WHEN: Late afternoon or early evening, when sunlight is soft with a golden color. If this is for your holiday card, the key is to take the photo months in advance so that the overall experience is more fun than stressful.

PREP: My rule of thumb is to have Mom wear what she feels most beautiful in and have everyone else's outfits complement hers. Find accent colors, tones, and shades for your family members. Stay away from logos that will distract from the emotions.

FOR P&S USERS: Disable your flash. Set the camera to Portrait mode for a low aperture number and slightly soft details.

FOR DSLR USERS: Turn off your flash, and set the camera to Aperture Priority mode, choosing a low aperture number of f/2.8. Some photographers advise to go higher in your f-stop number based on how many people are in the group photo. But if your group is all on the same focal plane, and you're standing six to ten feet back, they'll all be in focus with a low f-stop number, and you'll get a soft background at the same time. Set your camera to Continuous Shooting mode so that you can take several shots in rapid succession in case anyone closes their eyes.

COMPOSE: Since family members are all in a line, horizontal framing works best. The key is to close any gaps between bodies. The closer everyone is together, the more intimate the photo feels. Have Dad stand straight on in the middle with everyone else angled. Let the cuddly kids cuddle and the more serious kids stand straight and tall to reflect their authentic personalities.

CAPTURE: Focus on one of the parents in the middle. Take a second to make sure there is equal space on either side of your family, as well as a bit of space above heads and below feet. This will give you room in case your photo needs to be cropped for holiday cards or frames.

MY DSLR SETTINGS:
Aperture number was low,
at f/2.8, for shallow depth of
field. ISO was set to 400 for a
faster shutter speed to capture
any movement from the
youngest ones. Shutter speed
was 1/1000 sec. (1000).

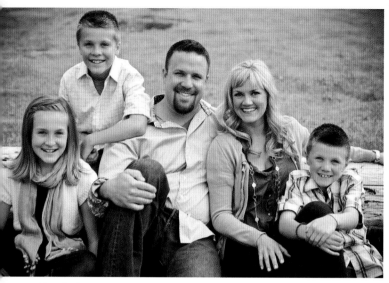

For the best results, have Mom wear what she feels most beautiful in, and then pick accessories and apparel colors for the rest of the family.

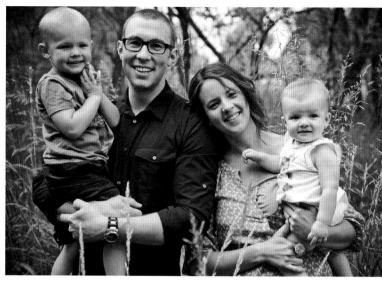

If your little ones are on the move, hold them for the family photo and choose a background that adds depth and texture, like a grass field.

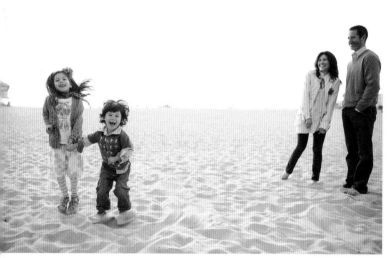

Branch out of the traditional family portrait by having the kids and parents on opposite sides of the frame.

Lynda Kennedy, a former CONFIDENCE workshop attendee in California, illustrates the idea of having the family lie on their backs with heads together.

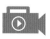 http://disney.go.com/disneyjunior/nightlight/merakoh

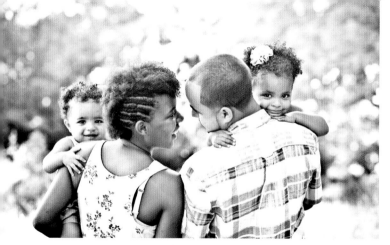

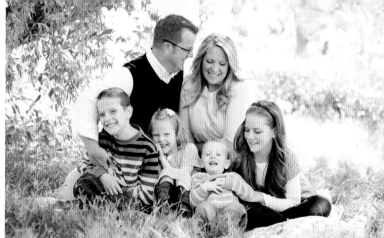

Lynda Kennedy captures a nontraditional family portrait by having the parents put their backs to the camera with the little ones peaking over.

Amy Rhodes, a former CONFIDENCE workshop attendee in Nevada, uses backlight to add a beautiful background glow to her family sitting in open shade.

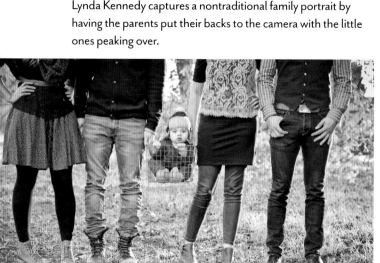

Above, left to right: Lynda Kennedy shows us a fun idea for a family portrait that only has baby's face showing.

Nikki McLaughlin, a former CONFIDENCE workshop attendee in Washington State, captures family portraits that tell a story of togetherness and joy.

Right: Neyssa Lee, a former CONFIDENCE workshop attendee in Washington State, does a wonderful job of showing us the beautiful difference afternoon lighting and "off-centering" your subjects can make.

tweens & teens

Photo by Bea Byers

n the first two books of this series, I focused on how to take pictures of babies and children. Tweens and teens are in a group of their own, balancing on the tightrope as they walk between the two worlds of childhood and adulthood. This is such a critical and awkward stage in life. It's tempting to set the camera down just to avoid conflict. After all, our tweens and teens aren't the only ones feeling awkward with this new stage. As parents, we often feel like we are in the dark with how to parent. What better reason to find common ground? Tweens and teens want opportunities to express their tastes, passions, and individuality. Can you think of anything more powerful than the camera to support them? The camera is not only a tool for documenting life but a powerful vehicle that can encourage their confidence and creativity. Be prepared to see the world in a whole new light as you creatively collaborate.

five tips
for photographing tweens and teens

1 **BEGIN BY BUILDING TRUST.** Due to the sheer awkwardness of this stage, tweens and teens are often trying to define their likes and dislikes while at the same time not being teased or ridiculed. Many tweens and teens now have smartphones and take hundreds of photos throughout their day-to-day lives. Set some time aside and ask them if they would share their photos with you. Acknowledge what you love about their eye, the light, the composition, and so on. This will build a sense of trust so that they feel more at ease to experiment with you and the camera.

2 **ALLOW FOR PREP TIME.** If your daughter didn't run to the mirror when she was ten years old, she most likely does now. It's even tempting to get frustrated when she insists on changing her outfit, but this is her authentic self at this stage in life. Set yourself up for success by allowing for this prep time, as part of the creative process.

3 **SHARE THE CREATIVE VISION.** There is a big difference between you wanting to take photos of your tween or teen and you having a creative project that you'd love your tween or teen's help with. When I need our own tween in photos, I often tell her about the project, what I'm looking for, and ideas of how she can help. I also let her know how much time it will take and what I see her doing in the photos. Sharing the creative vision feels much more inviting to her than Mom unexpectedly taking her photo with no warning.

4 **KEEP LIPS ZIPPED.** If inspiration doesn't come right away, and their ideas seem too bold for your comfort, keep your lips zipped. Art never begins with a final result, it's a creative process. Extend that same grace that you need to your tweens and teens as they suggest or try their own ideas (that may seem random at first glance). This is much more about being a safe person for them to practice creating with rather than impressing or wowing.

5 **DOCUMENT THE DETAILS.** Some tweens and teens love to have their photo taken, and others cover their face every time the camera comes out. If yours are the latter, spend time documenting the details that define who they are. Do close-ups of their favorite, worn-down tennis shoes. Capture the state of their bedroom. Take a series of their favorite books or objects that they've loved since they were little (like the worn-out teddy bear or the bottles of nail polish).

bedrooms

Tweens and teens are all about expressing themselves. Their bedrooms are the best places to do this. A wonderful exercise is to document their bedrooms as they evolve over the next eight years, whether they're in them or not. You will both cherish the documentation of all the special mementos pinned up, the wall colors they preferred during a certain season, or the favorite stuffed animals that have been around since they were little. And if their rooms are total disasters, you'll both get a laugh out of that too in years to come.

WHEN: Find a quiet time when your teen is in her bedroom and the window light is at its brightest.

PREP: Set up the room the way you want it remembered, whether this is the way it looks day to day or is a little less cluttered. Pose your child on the bed with a book, and move back to get as much of the room in the frame as possible.

FOR P&S USERS: Turn off the flash. Turn off all other lights in the room. Select Portrait mode for a lower aperture number. Play around with white balance settings to find the best color result for skin tones.

FOR DSLR USERS: Turn off the flash. Turn off all other lights in the room. Set your camera to Spot Metering. Select Manual mode. Start at ISO 400 since you are inside, and choose a lower aperture number, like f/2.8. Take a few test shots to see if the color and exposure are to your liking. If you need more light, lower your shutter speed, but once you hit 1/60 sec., you'll want to raise your ISO. Play with different white balances to get the results you like.

COMPOSE: For a bed shot like this, horizontal framing works best to get in a lot of the elements of the bedroom, with the child close to center. Consider tilting the camera slightly to add a sense of motion, as if you've just walked into the room.

CAPTURE: Focus on your child's head and shoulders. If those elements aren't centered in the frame, reframe to center them, and lock focus and exposure; then return to your original composition and fire.

MY DSLR SETTINGS:
Aperture was set to f/2.8 and ISO to 400. Shutter speed was 1/60 sec. (60).

tween self-portrait

Being a tween is the most awkward stage of life. Tweens aren't old enough to drive and be out with friends. But they feel too old to run around with younger siblings and neighborhood kids. And their bodies are changing with each passing week. How can they not be a bit preoccupied with how they look and what they wear? All these shifting elements lead to tweens being enthralled with taking self-portraits. If you have a tween, you know exactly what I'm talking about. Why not hand the camera over and encourage her creativity even more?

WHEN: Any time your tween is looking for something to do that allows her to be creative and experiment.

PREP: Give her some tips on shooting in late afternoon or including props. Prepare yourself to not see her implement your ideas right away but most likely when you aren't paying attention. While working one day, Brian spotted Pascaline carrying her bedroom couch out to the front yard. He acted like he didn't notice, but he couldn't help but smile.

FOR P&S USERS: Turn off the flash. Set the camera to Portrait mode so that there is blur in the background. Show them how to set the self-timer with enough time to get in the shot.

FOR DSLR USERS: Turn off the flash. Set the camera to Aperture Priority mode, and pick a lower f-stop number for her (or let her pick her own, like Pascaline did). Show them how to set the self-timer or set up an app to use a smartphone as the shutter trigger (that's what Pascaline used for her photo). We often put the camera in Manual mode for the kids, set their ISO, and show them how to choose an f-stop and a shutter speed to make the photo brighter or darker. They love playing with the camera settings versus being in Auto mode.

COMPOSE: Walk through different photos with your tween to show her why she may want horizontal or vertical framing, or just let her have at it. It's amazing how creative our kids are with no instruction! Since this is a self-portrait, show her how to use a tripod. Or maybe she'll experiment with setting the camera on the sidewalk, like Pascaline did.

CAPTURE: The look and feel your tween is trying to convey will determine her focus point. I love how Pascaline chose to focus on the grass versus herself. Again, our kids' creativity and experimentation always inspires me.

KIDS AND TECHNOLOGY

Where many parents might feel intimidated by technology, kids eat it up. My kids often experiment with the latest picture effects and photo apps that I haven't even tried yet. They are always opening my eyes to new technology and ideas for what you can do with photos. Encourage your tweens to play with the family camera, too, and show them how to handle it with care. Be prepared to be blown away by what they come back with. Pascaline loves the app called "Smart Remote" which allows you to trigger the camera's shutter with your smart phone. She will often spend hours setting up different self-portraits or photo shoots of her lazy, sleepy cat. These are some of my most treasured photos, where I get to see her creativity evolving.

DSLR SETTINGS: Aperture was set to f/5.6. ISO was 100 for best color saturation. Shutter speed was 1/80 sec. (80). Photo by Pascaline Tausend

friends forever

Surviving the tween and teen years is all about the friends our kids surround themselves with. This stage in life is filled with so much physical and emotional change that friendships feel like pure sunshine when life feels overwhelming. Before your teen prepares to leave for college, carve out time to do a special photo shoot of her and her BFFs. Bea Byers, a former CONFIDENCE workshop attendee in Florida, captures a darling series of photos of girlfriends. Friends will come and go, but childhood friends are often the most treasured.

WHEN: Late afternoon when the sun isn't overhead and shadows aren't harsh.

PREP: Find a location like a beach or a park that has a lot of flexibility, with a range of options for seated poses and walking shots. Encourage them to talk and laugh with one another for more natural-looking shots.

FOR P&S USERS: Turn off the flash. Select Portrait mode so that the focus will stay on the faces. Consider using black-and-white mode for some shots, to add variation.

FOR DSLR USERS: Turn off the flash. Select Aperture Priority mode, and choose a lower f-stop number to soften the background details. Boost the ISO if necessary to keep the shutter speed higher.

COMPOSE: Horizontal framing works best for a large group. Experiment with sitting and standing poses, or even a mixture of both. Have your group walk away from you for some shots and walk toward you for others. Have everyone look at one friend and try to make her laugh. Encourage everyone to throw their heads back and do a fake laugh. The moment will feel awkward, but the genuine giggles that follow are perfect for great shots.

CAPTURE: Focus on the face closest to the center of the frame. If your group is spread in a line in front of you, most of the faces should be on the same focal plane. If there isn't a face at the center, reframe to center the closest and lock focus; then go back to the original composition and fire.

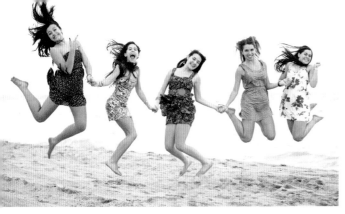

DSLR SETTINGS (top left): Aperture was set to f/2.8. ISO was 400 for best color saturation. Shutter speed was 1/250 sec. (250) to freeze the action.

DSLR SETTINGS (top right): Aperture was set to f/3.2. ISO was 250 for best color saturation. Shutter speed was 1/250 sec. (250).

DSLR SETTINGS (bottom left): Aperture was set to f/3.2. ISO was 250 for best color saturation. Shutter speed was 1/320 sec. (320).

DSLR SETTINGS (bottom right): Aperture was set to f/2.8 to soften the background. ISO was 640 for more light. Shutter speed was 1/80 sec. (80). Photos by Bea Byers

VERBAL AFFIRMATION IS KEY

Everyone feels self-conscious in front of a camera, but for tweens and teens this is especially true. To encourage a fun, free energy, give continuous verbal affirmations as you shoot. Tell them how great they look, how cute their outfits are, how fun they are, how beautiful their smiles are, how pretty their laughter is when they lean into one another, and so on. Give as many verbal affirmations as you can to keep their minds off of how silly or self-conscious they feel. After a handful of shots and your verbal affirmations, you'll notice how they are tuning in more and more to what you're saying, which helps them laugh and smile with ease.

performances

Your son or daughter has been rehearsing for months. The performance is finally here! You want to capture the best photo, but the stage is so far away, the lights are always changing, people's heads are blocking your view, and there is constant movement. To overcome all these obstacles and capture a great photo, you need a solid strategy. Nicole Elliott, a former CONFIDENCE workshop attendee, inspires us with this wonderful action photo. Follow the photo recipe to set yourself up for success; the impossible photo is about to become possible!

WHEN: During any stage performance, when you can snap a few images and also enjoy the show.

PREP: Get familiar with the performance timing beforehand so that you know approximately when your child will appear onstage and for about how long. Arrive early enough to find the best vantage point, and adjust your equipment accordingly—you may or may not have room for a tripod, and you'll want to choose your lens based on where you're sitting. If you can do some test shooting during dress rehearsal with the lighting setup, you'll know what your camera settings need to be so that you're not fumbling with controls during the show.

FOR P&S USERS: Turn off the flash. Set the camera to Portrait mode for a low aperture. Boost the ISO enough to get a fast shutter speed that will freeze movement and still get a bright exposure. Consider using Continuous Shooting mode so that you don't miss a step. Get as close to the stage as possible, since you are limited by the point-and-shoot's zoom quality and length.

FOR DSLR USERS: Turn off the flash. Select Manual mode, and choose the lowest aperture. Adjust the ISO high enough that you can get a bright exposure with a fast enough shutter speed to freeze movement. If there's fast movement, you'll want your shutter speed to be around 1/500 sec. (500) to freeze the action. To cover yourself, use Continuous Shooting mode so that you can shoot rapid-fire and pick the best image later. With the multiple stage lights involved, it's better to choose Auto white balance and correct it later. If your high ISO is causing grain, you can fix it later with photo-editing software. The key is to not miss the moment and to shoot as much as possible.

COMPOSE: Horizontal framing will get the most of the stage and set. Use the zoom to crop out any distracting stage elements or extra negative space. Or use negative space to accentuate the direction of the performer's movement.

CAPTURE: Focus on your child's body. If it's not in the center of the frame, reframe to center it, and lock focus and exposure; then reframe to your original composition and fire away.

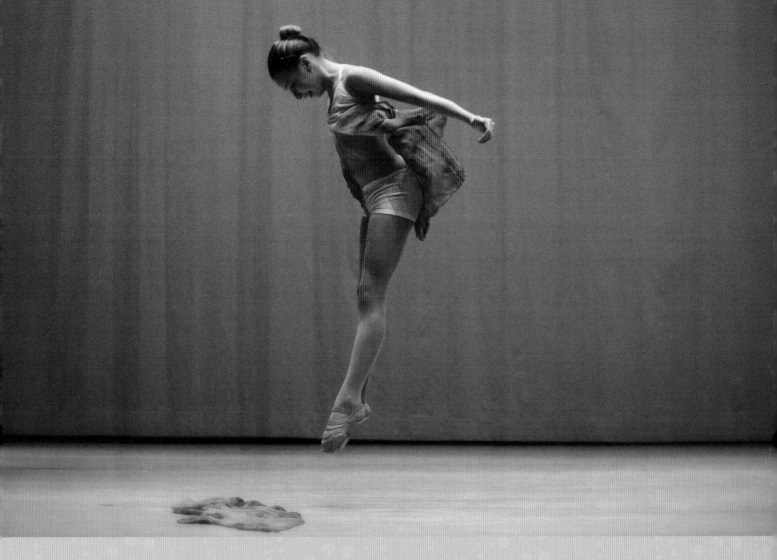

DSLR SETTINGS:
Aperture was at f/4,
ISO was set to 1600,
and shutter speed was
1/200 sec. Photo by
Nicole Elliott

senior portraits: girls

When I first started taking clients, I worked with a lot of high school seniors. I loved how the girls would come with four or five different outfits, matching jewelry, different shoes, and the boys—well, if Mom won, they'd just show up. Soon-to-be-seniors are on the brink of beginning a new stage in life as they transition from teen to adulthood. I love how Cheryl Bidleman, a former CONFIDENCE workshop attendee in Washington State, says that "after this year, so many things will never be the same." That's the reason why this is such a special photo shoot to experience with your teen.

WHEN: Midmorning or late afternoon, when the sun isn't directly overhead.

PREP: Set some time aside to talk with your teen about what she'd like to express in her senior portrait, what outfit she loves most, and the like. Find an outdoor location that's special or picturesque and, if possible, somewhat private with a bathroom nearby for changing outfits.

FOR P&S USERS: Turn off the flash. Select Portrait mode to soften background details.

FOR DSLR USERS: Turn off the flash. Select Aperture Priority mode, and choose a lower aperture number like f/2.8. If your teen is giggly, consider Continuous Shooting mode to capture several frames per second to increase your chances of catching the most flattering giggle shot.

COMPOSE: Vertical and horizontal framing both work well, because both can keep the focus tight on the face and body, leaving only a small amount of background to set the tone. Changing the framing also adds variety to the overall series of photos. Play around with posing and angles, get down low, get in close, and find compositions that inspire you.

CAPTURE: Focus on the face. If it isn't in the center of the frame, reframe to center it and lock focus; then return to the original composition and fire.

INVITE HER FRIEND

If she's feeling anxious about the photo shoot, ask her to invite a friend. This can help relax your teen and make the experience more fun. Her friend can help you elicit genuine smiles and giggles versus the stiff, posed smile. And it's a wonderful oppor-tunity to capture their friendship at the end. Be forewarned though: if your teen daughter loves the idea of having a few different outfits, plan on the shoot taking up to two hours.

DSLR SETTINGS (all images): Aperture number was low at f/2.5 to soften the background. ISO was set to 100 for bright light. Shutter speed was 1/200 sec. (200). Photos by Cheryl Bidleman

senior portraits: guys

Senior portraits for guys can be so much fun! Boys are often low maintenance and surprisingly open to trying anything you suggest. (I think the tougher part is just getting them to participate in senior portraits; once that battle is won, they're usually superengaged.) Layering their clothes is key for different looks in a series of photos. Switching from a letterman's jacket to sweater to favorite T-shirt can change up the look and feel without making it a big wardrobe issue.

WHEN: Morning or late afternoon, when sunlight isn't as bright. Overcast days are great.

PREP: Unlike your senior girls, guys don't tend to be as interested in discussing the shoot's vision ahead of time. Instead, do the legwork yourself beforehand. Find colorful walls, alleyways, garage doors in urban settings, or subtle textures to make interesting backdrops. Invite them to bring props that have special meaning, like a basketball (if they play on a team), skateboard, or guitar.

FOR P&S USERS: Turn off the flash. Select Portrait mode to focus on the face.

FOR DSLR USERS: Turn off the flash. Select Aperture Priority mode, and set the aperture number low, f/2.8 or less, to keep facial features sharp and soften the background slightly.

COMPOSE: Vertical framing fills the composition with your son. Get in close, and frame from midtorso up. Play around with camera tilts to get a composition you like. Consider also having him squat and look up at the camera so that you're shooting down on him. This is a strong, masculine-feeling pose for young men.

CAPTURE: Focus on the face. If it isn't centered in the frame, reframe to center it and lock focus; then return to the original composition and fire.

HUNT FOR COLOR AND TEXTURE

Look for colorful walls and textures to add vibrancy and depth to a senior portrait. The most unlikely chipped orange wall on the back of a building can be the perfect backdrop against a letterman's jacket with contrasting colors! The more you look, the more treasures you will find in everyday settings you've seen a million times. But make sure you do this search during the time of day you plan to shoot, because the light's positioning will affect everything.

MY DSLR SETTINGS: Aperture number was low at f/2.8. ISO was set to 400, and shutter speed was 1/400 sec. (400).

prom!

When you think of all the days your little girl played dress up, senior prom seems unbelievable. So much planning and primping goes into this one event, from finding the perfect dress and matching shoes, to the hairstyle and jewelry. You want to capture this event, and you know you only have a short window of time before the two head off. The key to getting great photos is to be prepared! Tracie Steir-Johnson, a former CONFIDENCE workshop attendee in Wisconsin, shares a wonderful, fun photo series of how she captured this special event for her daughter. This mama had a photo plan in mind. Let the photos and photo recipe help guide the way for creating your own photo plan.

WHEN: Late afternoon but early enough so that you don't interfere with the evening's festivities. If your subjects are game, you can also try setting up the shot the weekend before the event.

PREP: Before prom night arrives, scout out a flexible outdoor location with lush greenery and enough wide-open space to move around in. Clean paths and ample green space add depth and movement. Have your teens go through a number of poses, some serious and some funny, for a good range of images that reflect the event and their personalities.

FOR P&S USERS: Turn off the flash. Select Portrait mode for a blurred background. Consider shooting a few images in black-and-white mode for a more classic feel.

FOR DSLR USERS: Turn off the flash. Select Aperture Priority mode, and dial down the f-stop to f/2.8 or f/2 to keep focus on the couple. For silly or dancing shots, set your camera to Continuous Shooting mode so that you capture every last second.

COMPOSE: Vertical framing is a great option to get the most of both the dress details and the tuxedo. But also experiment with distance, getting close and then zooming out to full body for a variety of pictures. When they are being silly or dancing, experiment with camera tilt to accentuate the motion and feeling of immediacy.

CAPTURE: Focus on the face closest to center (both faces should be close to the same focal plane) or the one closest to you. If there isn't one directly centered, reframe to lock focus, and then return to your original composition and fire.

DSLR SETTINGS:
Aperture number was fairly low at f/2.8. ISO was high, at 2500, because of heavy tree cover. Shutter speed was 1/4000 sec. (4000). Photos by Tracie Steir-Johnson

graduation

I've been told that the single thought "I am the mom of a graduated senior" can pull at your heartstrings like nothing has before. You see your strong and confident child accepting her diploma with sheer joy, and you feel a mixture of both overwhelming pride and grief. All the more reason to listen to the wisdom of Beth Wendland, a former CONFIDENCE workshop attendee in Oregon, and take photos prior to graduation weekend. Since she planned a time with her daughter to take that cap and gown for a trial spin, they were able to enjoy the photo experience (and let reality settle in at the ceremony).

WHEN: Pick a time before graduation when both you and your graduate are relaxed, preferably in the early evening hours when the light is still bright but soft.

PREP: Let your graduate choose a location that's special and unique to her personality. Find a spot with multiple posing options for sitting or standing, where the background won't be too distracting.

FOR P&S USERS: Turn off the flash. Choose Portrait mode to soften background details.

FOR DSLR USERS: Turn off the flash. Select Aperture Priority mode, and dial down the f-stop as low as you can to get a nice blurry background.

COMPOSE: Horizontal framing will work nicely here, getting in the cap and part of the gown, but play around with vertical framing as well. Get in close so that the focus is mainly on your graduate's emotion. Experiment with serious and fun poses to get a full range of feelings on this big milestone.

CAPTURE: Focus on the eyes. If they're not in the center of the frame, reframe to center them, and lock focus and exposure; then return to your original composition and fire. Don't forget to grab close-up detail shots of the cap, tassel, and even the graduation announcement.

THE KEY TO GREAT GRADUATION PHOTOS

Don't wait until the big day arrives. Between fighting the crowds and the excitement of graduation night, success with getting a great photo will most likely prove to be disappointing. Instead, find a time when you and your senior can have fun getting shots, taking that cap and gown for a trial run, and not have any outside pressures adding stress.

DSLR SETTINGS:
Aperture number was very low at f/1.4. ISO was set to 100 due to ample outdoor lighting. Shutter speed was 1/1250 sec. (1250). Photo by Beth Wendland

family vacations
& travel

"We travel not *to* escape life, but *for* life not *to* escape us."
—ANONYMOUS

amily trips are a passion that my husband Brian and I share. But it's often a mixed bag of goods. There is a sense of escape but also a growing stress as you compile the list of things to pack. Memories of running down the beach, kids learning to ski, or camping alongside the river are unforgettable. But there are also the possibilities of sick days, flat tires, missing luggage, and cancelled flights. As parents, we can almost feel like the list of things that could go wrong far outweighs the simple ease of just staying home. Yet when your family finally pulls out of the driveway and hits the road, a magic begins to unfold. A journey filled with adventure, laughter, and anticipation begins. A special bond starts to build as you all step into the unknown together—an experience that can't be had in the familiarity of home. With the following photo recipes as guidance on what and how to capture the milestones of your travels, your family can revisit your trips in years to come, as if the adventures were only yesterday.

five tips

for photographing vacations and travel

1 **IN THE BEGINNING, KEEP THE GEAR PACKED.** When you first visit a new place, your creativity is so stimulated that it's tempting to shoot everything you see the first two days. This is the fastest way for your kids to feel disconnected from you, which creates resistance to being in the photos later. Avoid this by keeping your camera gear packed away for the first part of your trip and focusing on bonding with the family.

2 **TAKE NOTES AS YOU RESEARCH.** Even though the camera gear is still packed the first few days, this doesn't mean you can't do great research by being observant. Make note of what time the sunset light is most golden. Notice which surroundings show off the light best. Research the quietest spot on the beach, around the monument, or on the mountain where you can take some great photos while avoiding tourists. The better the research, the more you set your shooting up for success.

3 **START WITH A LOW ISO.** Since you will be shooting outside a majority of the time, start with the lowest ISO possible for best color saturation.

4 **BE THE EARLY BIRD.** When I asked a friend of mine, who is a *National Geographic* photographer, how he gets such amazing light in his photos, he said, "Because I force myself to get up before dawn, so I'm in place to shoot before sunrise." On your next family adventure, pick a special setting and one morning to be the early birds. Get the family up before sunrise for the shot. Yes, it's painful. But the family will talk about it for years to come (not to mention the gorgeous light you'll capture).

5 **CAPTURE A SENSE OF SETTING.** If you're like me, you love taking photos of people, which also means you are often zoomed in or framing tight on the subject versus shooting wide. But when traveling, you want to make sure to capture a sense of the setting so that people know it wasn't just the beach down the road but the beach in Thailand with the limestone cliffs in the background.

a day at the beach

The beach is one of the best playgrounds for a child's imagination. Hours disappear as your family builds sand castles and takes turns burying one another in the sand. There's a playful teamwork that happens, which is the perfect energy for family pictures. Instead of trying to fight the sun with eyes squinting and harsh shadows, turn the family around and put their backs to the sun. As the evening draws near, the light will become more and more magical!

WHEN: Late afternoon at the beach, when the sun is getting lower in the sky but is still bright. Also, wait for the kids to let loose with playing in the sand so that they aren't camera-conscious when you go to take the photo.

PREP: Set up your kids playing in the sand with the water and sun behind them. Getting enough light (and not too much light) on their faces is all about subtle shifts in your position. Before you lift the camera to your eye, prep as much as you need to so that you find a spot where not only can you see all their faces and expressions but they are also turned away from the bright sun.

FOR P&S USERS: Turn off the flash. Select Portrait mode for a lower aperture number. Due to the limits of a point-and-shoot, you may need to consider increasing the ISO to brighten the shadows to avoid a silhouette result. If you're using a smartphone, tap on your subject to increase the light on them and brighten the background.

FOR DSLR USERS: Turn off the flash. Dial your ISO down as low as possible because of all the light. Select Manual mode, and set a low aperture number; then find a fast enough shutter speed to freeze movement without getting the shadow areas too dark. Start with the shutter speed I used to get you close to the lighting you want, and then finesse your shutter speed from there. Play around with the exposure, and don't worry about blowing out the background highlights.

COMPOSE: Horizontal framing gets most of the children in the frame, with enough sand and water to set the scene. Get low and close.

CAPTURE: Focus on the face closest to the center of the frame. If it's not directly at center, reframe to center it and lock focus; then go back to your composition and shoot.

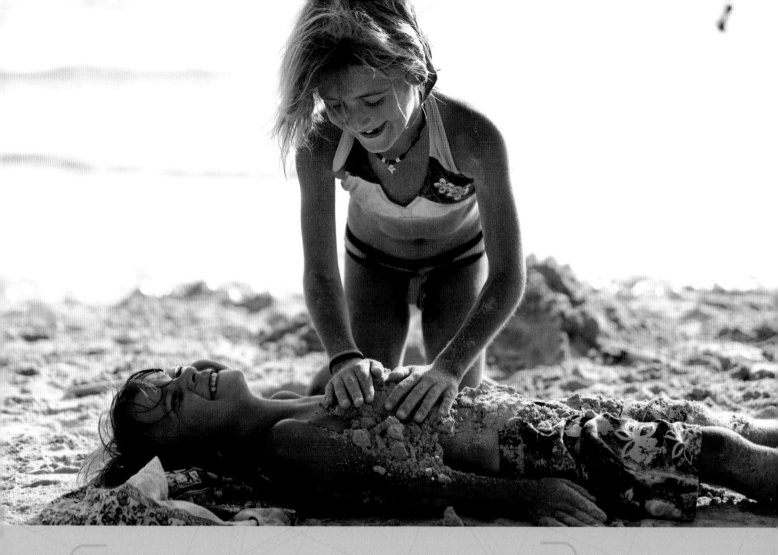

CRAZY-FAST SHUTTER SPEEDS!

Don't be alarmed if your shutter speed is at the fastest setting it can go. There is so much light being reflected from the sand (this is true for snow, too) that the shutter can't stay open long at all. If your shutter speed is as fast as possible and your images are still turning out too bright, you want to "take away" light. Make sure your ISO is as low as possible. Still too bright? Adjust your f-stop to a higher number (a smaller aperture opening).

MY DSLR SETTINGS: Aperture number was low at f/2.8. Due to the bright sun being reflected from the sand and water, a low ISO of 200 was perfect. Shutter speed was 1/1600 sec. (1600).

snow day!

Snowy days are what every child prays for. Just an inch or two of snow is all the kids need to be elated. Once we have them dressed in dozens of layers, we watch them wobble to the first patch of snow and fall backward, spreading arms and legs to make snow angels, sticking out tongues to capture every snowflake possible, building snow forts as they dodge Dad's ruthless snowball aim, asking Mom to help build the snowman. And the quiet magic of a fresh snowfall seems to make everything new again. Wonder and joy are in the air! What better combination for grabbing your camera to document the family's snow day!

WHEN: Early morning or late in the afternoon on bright days, or anytime on an overcast day.

PREP: Find an out-of-the-way spot where your kids can take a break and you overlook the scenery. Earlier in the day will be best for younger children, before they're tired from the slopes and ski school.

FOR P&S USERS: Turn off the flash. Select Landscape mode or Snow preset if your camera offers it. Experiment with any creative filters that boost vibrancy of color if available.

FOR DSLR USERS: Turn off the flash. Select Aperture Priority mode, and choose a moderately low f-stop number, like f/2.8 or f/2. Keeping ISO low, play around with settings until you get a faster shutter speed, like the 1/500 sec. (500) used here. Snap a few test images to check color and exposure.

COMPOSE: Vertical framing gets enough of the tree-laden mountainside in the upper portion of the image to prevent the image from being blindingly white. The trees also add depth and dimension with a little color. Use the Rule of Thirds to divide up the image, placing your kids in the lower portion with a snowy hill followed by trees taking up the rest.

CAPTURE: Focus on your kids. Reframe the composition to put them in the center and lock focus; then go back to the original framing and fire.

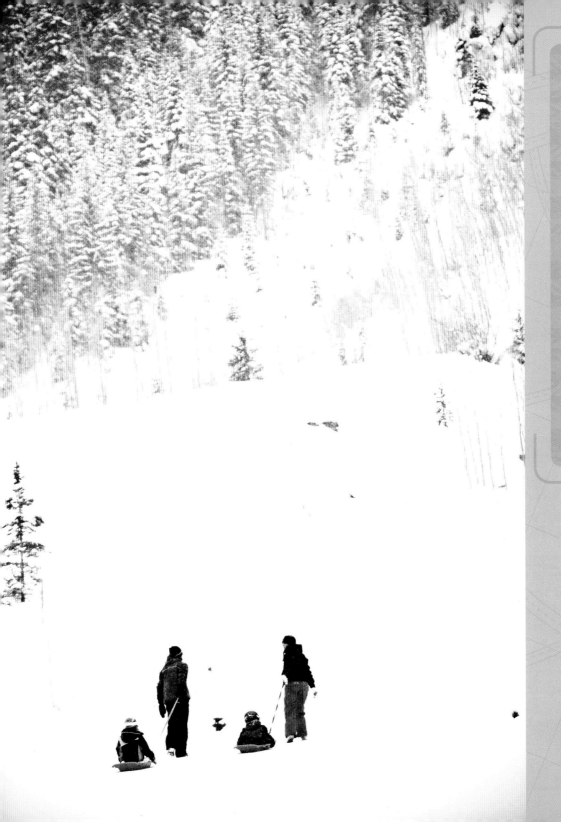

Oftentimes, kids are the only elements that aren't white in a snow photo. To create a richer story, we want to stay away from an all-white setting. The trick is to find ways to frame trees, homes, or even ski lifts in your snow photos, too. This not only adds more color but, more important, adds greater depth and texture to an all-white setting.

MY DSLR SETTINGS: Aperture number was lower at f/2.8. ISO was low at 160 due to the bright white background. Shutter speed was 1/500 sec. (500).

the great outdoors

Whether you're an outdoor person or a hotel type, the experience of taking the family camping is unforgettable. There are so many wonderful photo opportunities! My favorite camping photos are the ones that capture not only the family having fun but the overall scenery of the great outdoors. I especially love how Tina Erdmann, a former CONFIDENCE workshop attendee in in Wisconsin, zoomed in enough to capture the lake, trees, canoe, and glistening water—all part of her story.

WHEN: Either early morning when sun is still climbing or late afternoon as it is sinking in the sky but is still bright.

PREP: Position yourself along the shoreline, and find your best vantage point before having the canoe cross into the frame.

FOR P&S USERS: Turn off your flash, and set your camera to Landscape mode to ensure that both foreground and background are in focus. Consider using Continuous Shooting mode to freeze action and enable rapid firing as the canoe passes.

FOR DSLR USERS: Turn off the flash. Set your camera to Aperture Priority mode, and choose a setting of f/4 or f/5.6 to ensure that as much of the scene will be in focus as possible. Consider using Continuous Shooting mode to freeze your moving subject. Catching paddlers in midstroke gives a sense of movement, as does any rippling water or paddle spray.

COMPOSE: A horizontal format works best here, capturing the long canoe as well as the landscape around it. Waiting for the canoe to hit the center of the frame leaves room for glistening sunlight in front and the trailing rope behind, which conveys motion. Keeping the canoe in the lower third of the frame balances out the water, land, and sky elements as well. But play around with leaving empty space that the canoe is moving toward for a slightly different look and feel.

CAPTURE: Since this is a moving subject, focus on the middle of the canoe, and track it until it hits the right point in your composition. Rapidly fire several shots until you lose your composition; then start again if needed.

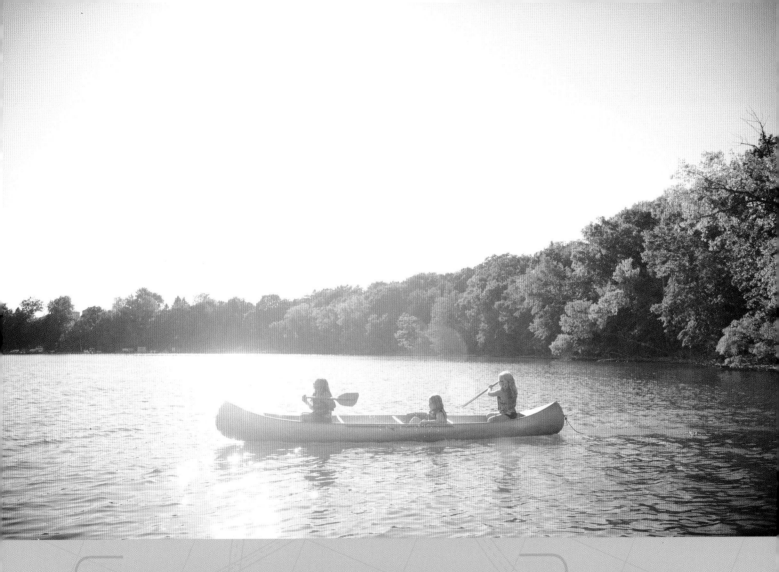

WHEN GLARE ADDS TO THE STORY

We often think that glare from the sun diminishes the photo. But consider the story you want to tell. Glare on a lake can convey a serene and calm atmosphere and can actually accentuate the overall peacefulness of the story. To capture more glare in your images, slightly lift your lens to allow direct sunlight to hit the lens. You can often see the glare or bokeh rings when you look through the viewfinder. Make subtle adjustments with the lens position to determine how much glare your story needs.

DSLR SETTINGS:
Aperture was f/4 to allow for more detail in the background and because of the bright backlighting. ISO was set to 200, and shutter speed was very fast at 1/1000 sec. (1000). Photo by Tina Erdman

sunset silhouettes

One of my favorite family pictures is the sunset silhouette. The black "cutout" shapes of each person remind me of the die-cut profiles we used to do in grade school. There is a timelessness that comes from a sunset silhouette. And what's funny is that if your kids are feeling fussy from a long day at the beach, we won't see their faces anyway! This family picture is more about capturing the amazing sky and the height differences of your little ones next to you. The key is to not have any objects that blend with your body silhouettes, like trees or mountain ranges, as Amy Rhodes, a former CONFIDENCE workshop attendee in Nevada, illustrates so beautifully.

WHEN: Right before sunset, when the sun is on the horizon or very close to it.

PREP: Find a location with a slight hill so that the figures can be positioned above you. For this shot, Amy lay down on the ground and tilted her camera up.

FOR P&S USERS: Turn off the flash. Choose the Sunset mode. If this auto mode isn't giving you the desired results, focus on your subject and then tap the sky to make the family dark. (Many point-and-shoot cameras now have a touchscreen that allows you to adjust brightness by tapping within the frame.)

FOR DSLR USERS: Turn off the flash. Select Aperture Priority mode, and choose a high aperture number, like f/16, since you'll be shooting directly into very bright light. ISO can stay low. Take a few test shots to see if you're getting a good enough silhouette. If your subjects aren't dark enough, or the background is too bright, consider switching to Manual mode and adjusting the shutter speed until you get the results you're looking for.

COMPOSE: A horizontal format will work best to get the full family in the frame as well as enough of the setting. Make sure that everyone is on the same plane. Amy's tip is to pretend that everyone is standing on an imaginary line, like the horizon line at the top of the hill.

CAPTURE: Find a spot near the center of the frame where a black silhouetted figure meets the bright sky. The camera can have a hard time finding focus in shots like this, so play around with framing until it finds a spot to lock on. Or you may have to switch to manual focus. Once you find and lock focus, reframe to your original composition and fire.

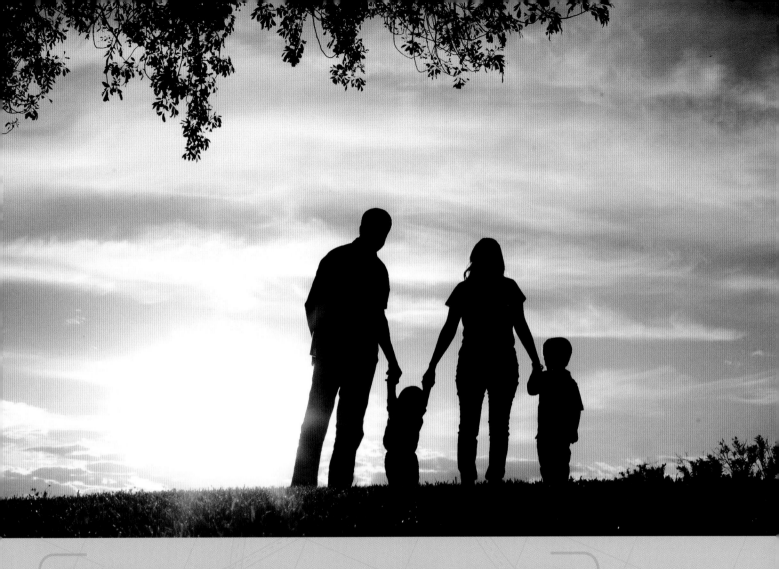

SMARTPHONE SILHOUETTES

Silhouettes are so easy to get with your smartphone. When you're taking a silhouette, you are technically exposing for the bright area of the photo instead of the people. When you expose on the sky, everything else will fade to black. Did you know that when you're taking a picture with a smartphone, you can tell the camera what area to expose? Once you get your subjects set and are ready to take the picture, hold your phone up to take the shot. Now tap on the sky. By doing this you are telling the camera that you want to expose on the sky instead of the people. Once you have tapped on the sky, you should see the people on the screen become black. Voila! You're ready to take the shot.

DSLR SETTINGS: Aperture number was high at f/16 to compensate for the bright sun. ISO was set to 200 to reduce grain, and shutter speed was 1/350 sec. (350). Photo by Amy Rhodes

amusement parks

Every child dreams of a family vacation to their favorite amusement park. But the actual experience can be exhausting. Instead of getting overwhelmed with trying to capture every moment, pick your favorite two or three rides, and use this photo recipe for great results. Katrina Schoepflin, a former CONFIDENCE workshop attendee in California, is a huge Disney fan and dreamed of having a family photo on the Dumbo ride. She wanted to be in the photo so she set up the camera beforehand for her sister. Since this was a magical ride, she wanted magical backlighting with the sun behind them as her sister shot away. These simple prep steps and the recipe below will make all the difference between a magical photo and a snapshot.

WHEN: While visiting an amusement park early in the day, before the sun gets too high in the sky, or later in the afternoon, when lighting isn't too harsh and has a warm look.

PREP: Find a good vantage point next to the ride from which you can see your family clearly, and set your camera settings. If someone can help you, hand off your camera and tell them to fire away as you come by, or they can also sit in the ride in front of you. If you're grabbing the shot, train your lens on the center of each car so that you're ready when your family passes.

FOR P&S USERS: Turn off the flash. Set the camera to Portrait mode to enable a low aperture number. Since you're outside during the day, you've got plenty of light for a low ISO to get best color. If your camera has a Sports mode, consider using it to help freeze movement.

FOR DSLR USERS: Turn off the flash. Select Manual mode. Choose a lower f-stop for the buttery blurred background. If you have plenty of sunlight, choose the lowest ISO possible for best color saturation. For an amusement park ride, you want to make sure your shutter is moving fast enough to freeze the action. Anywhere between 1/500 sec. to 1/5000 sec. will work. How fast your shutter speed goes will all depend on how much daylight you have to work with. Use Continuous Shooting mode so that you can quickly grab as many exposures as possible as the ride passes by.

COMPOSE: Stick with a horizontal format, and fill the frame with the car as it passes by (you'll want to practice framing on the ride before your family passes you). Find an angle that has your child or family's faces coming toward you before the car passes by.

CAPTURE: Focus on the center of the car. Because of the speed of the ride, aim the lens at the center of the car and lock focus (all of your family's faces should be in the same focal plane); then fire the shutter.

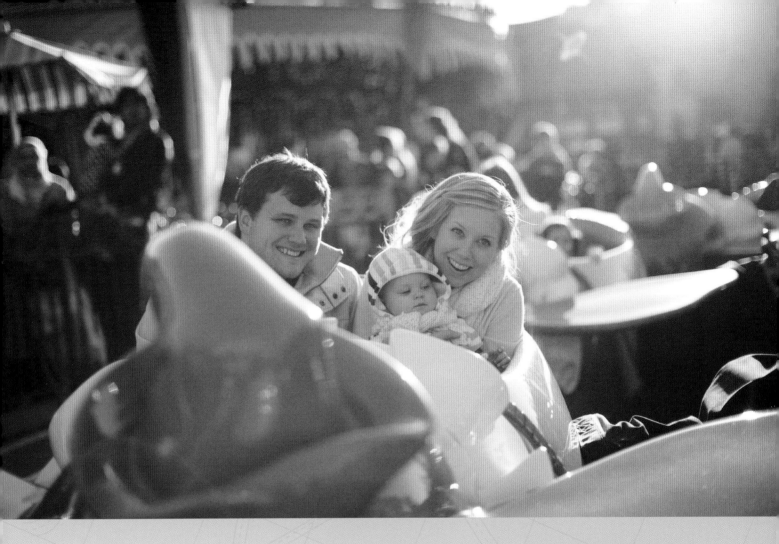

DSLR SETTINGS: Aperture number was low at f/1.6. ISO was set to 160 because of the bright daylight. Shutter speed was 1/5000 sec. (5000) to freeze the action. Photo by Katrina Schoepflin and Krissy Traustason

hotels

Your hotel room may seem like the last place you'd think to take a family picture of your vacation, but it's a fun one. Windows are often huge, providing a wonderful source of backlight. Plus, the hotel room is a place of rest after a day at the beach or touring a city. As Mom and Dad get ready for dinner, kids tend to find their own quiet places to take a break. When I found Pascaline under the hotel desk, quietly playing a game on her iPhone, I couldn't resist the photo op!

WHEN: During downtime in a hotel room when ample light is flooding the windows.

PREP: Find a quiet moment either before setting out for the day or in the afternoon when everyone is back and taking a break. Set up on the floor for an eye-level shot, or lie on the bed if your child is relaxing there.

FOR P&S USERS: Turn off the flash. Select Portrait mode for a soft background and sharp focus on the face.

FOR DSLR USERS: Turn off the flash. Select Aperture Priority mode, and choose a lower aperture number, like f/2 or lower. Increase ISO if necessary to help brighten the shadows.

COMPOSE: In this image, horizontal framing includes the desk and edge of the bed in the composition, subtly indicating this is a hotel room. Get down low and use the floor to help steady your camera if using a slower shutter speed. A hotel room provides a wonderful opportunity to find unique perspectives, whether you lie on the floor or stand on the bed.

CAPTURE: Focus on your child's face. If it isn't centered in the frame, reframe and center the face to lock focus and exposure; then go back to your original framing and fire.

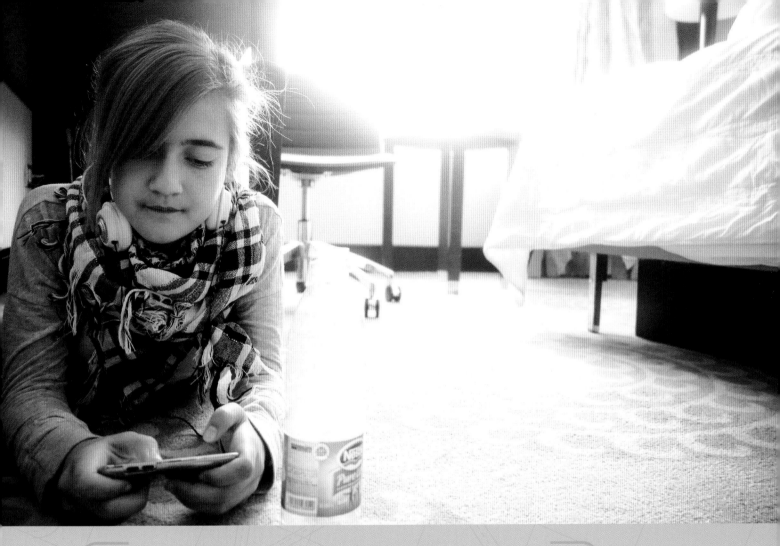

DRAMATIC BACKLIGHTING

If your results in Aperture Priority mode keep giving you a silhouette of your child, switch to Manual mode. Keep your f-stop low, but finesse your shutter speed depending on how much light you want on your child's face. The camera's meter will start to flash at you and say the photo is overexposed, but it's just talking about the dramatic backlighting from the window. We want that window to be overexposed for dramatic results! The camera doesn't always understand what results we are trying to capture. Finessing your shutter speed in Manual mode gives you the chance to be in charge.

MY DSLR SETTINGS:
Aperture was set to f/1.8. ISO was set to 800. Shutter speed was 1/80 sec. (80).

visiting the monuments

When your family visits monuments, you'll notice that almost everyone around is doing the typical tourist photos where they hold up their palm and it looks like the monument is sitting on their hand. As a mom and photographer, I want something more. But how do you take a photo of your kids and monuments when the kids are so small and the monument so huge? Action is the key word. Think of an action that your kids can do in front of the monument rather than just standing there and smiling for the camera. The action can be anything from a karate kick to walking a camel!

WHEN: Early morning or late afternoon when the sun is no longer overhead.

PREP: I usually end up visiting the monument twice. The first time is all about preparation. I'm looking to see where the sun is setting, what time the tourist traffic dies down, and if there are any guides I can hire to take us somewhere even more private for a better angle. The guide usually has tips to offer on different actions the kids can do, like when we were in Egypt, it was walking camels! But if you only have time to visit the monument once, try to plan the visit for late afternoon because tourist traffic tends to be highest during the first half of the day.

FOR P&S USERS: Turn off the flash. Select Landscape mode to get the monument details in focus as well as your kids in the foreground.

FOR DSLR USERS: Turn off the flash. Select Shutter Priority mode, and go for a faster shutter speed.

COMPOSE: Choosing horizontal or vertical framing depends on the actual monument. If you are visiting the Eiffel Tower in Paris or the Washington Monument in Washington, DC, a vertical might work better. For the pyramids in Egypt, a horizontal frame gave me the width to capture the whole family.

CAPTURE: Focus on the child who is closest to you. This is where our eye goes first when looking at the photo. If that child isn't in the center, reframe and center that face to lock focus. Then play around with your desired framing and fire.

 http://tinyurl.com/disneyjrMERAtravelphototips1

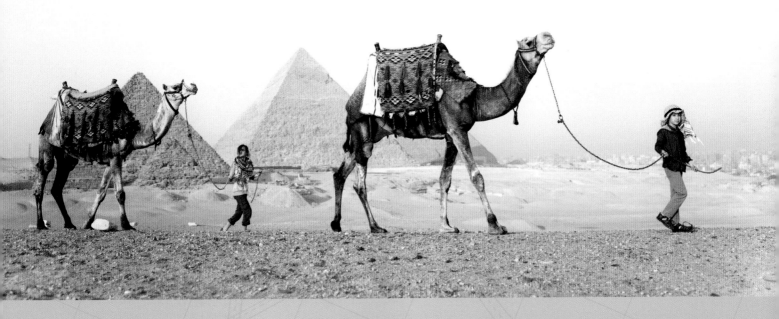

MY DSLR SETTINGS:
Aperture number was
low at f/2.8. ISO was set
to 100 because of ample
lighting. Shutter speed
was 1/640 sec. (640).

breathtaking landscapes with kids

Each of us tends to shoot the world wide or up close. I'm often in close, because I like the emotional connection and facial expressions of my subjects. But the best part of photography is that you can always challenge your own creative limits. I've been working on going superwide—capturing my family with big landscapes behind them—while still having an emotional component. The key has been to take a moment to find the vision for the photo before lifting the camera to my eye. Whether you're on a day hike, visiting the Grand Canyon, or camping in Egypt's desert with Bedouins, consider shooting your family in some type of action that includes a powerful landscape.

WHEN: Any time you find your family in the middle of a beautiful, wide-open landscape. The most ideal times for great lighting on the landscape are sunrise, late afternoon, or sunset. The color of sunlight is much richer and more golden, which takes our breath away.

PREP: Before you lift the camera to your eye, find your story. Once you lift the camera to your eye, your creative and literal vision is limited to the small viewfinder, so take the extra few minutes to find your story first. Refer to chapter 2 for fun ideas on how to find your story.

FOR P&S USERS: Turn your flash off. Set your camera to Landscape mode so that your subject and background scenery are all lit. If you want more attention paid to your subject, switch to Portrait mode for a softened background.

FOR DSLR USERS: Turn off your flash. Start in Aperture Priority mode; the amount of detail you want in the landscape will determine how low or high you set your f-stop. Set your ISO as low as possible for the best color saturation and vividness.

COMPOSE: Horizontal framing will most likely be your first choice to allow as much landscape in the frame as possible. But first notice the lines and curves in the formations around you. Let these natural elements inspire your composition. Determine how little or how much sky you want in the photo. What is the role of the sky? For this photo, the little bit of sky was about adding a rich blue color to accentuate the golden canyon.

CAPTURE: Since your family will most likely be standing at a distance from you, focus on their bodies. If there are multiple people, focus on the one in the middle, or the one who is drawing the most attention, because the eye will go their first. If no one is in the center, reframe and lock your focus.

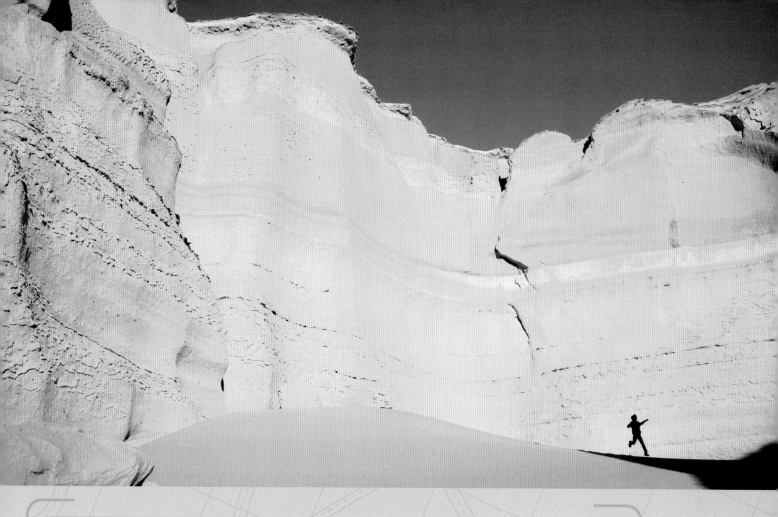

THE STAGES OF PHOTOGRAPHY

Growth and development in photography come in stages. We often want to be great at everything all at once, but the creative process doesn't work that way. In this photo in Egypt, Blaze was at the top of the hill. As he ran it, I metered my light for the shade and waited for him to get there. I knew his silhouette would stand out against the golden canyon. The first few years of taking pictures, I wouldn't have known what to do with my camera settings, let alone had a creative vision of the story. But after a decade of shooting, the camera has become a part of me, and changing the settings comes almost effortlessly. It takes time, but once you are there, it feels like you've just scratched the surface of your creativity. This is what your hours of practice, of trial and error, will bring you, too. Be patient: as you learn, you are documenting your family! How can you lose?

MY DSLR SETTINGS: Aperture was set to f/3.2. ISO was 200. Shutter speed was 1/2000 sec. (2000).

131

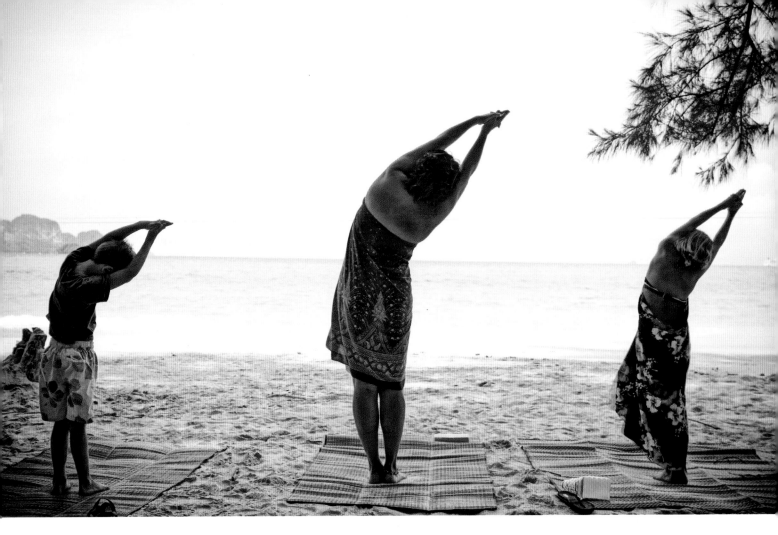

last words

as parents, we can easily limit ourselves when we feel uncomfortable while learning something new. Learning how to capture your family in pictures can feel exciting and overwhelming at the same time. In my weekly yoga class, I may wish my body was as limber as the woman next to me. But while I'm wishing for a body I've never had, I realize my kids are beside me, looking to me, mimicking my stretch, modeling what I'm doing because they don't see any flaws or shortcomings. Photography is the same way. My willingness to continuously develop and challenge myself creates space for the kids to approach their passions as a learning process.

There's a poem posted in my yoga studio. Halfway through it is a single line that speaks to me every time: start from where you are. The sentence is so simple and yet something I need to remind myself of. I so often want to start my creative process from anywhere but where I am. I want to start writing a book when it's almost done, not with the first blank page staring back at me. I want to play classical piano as if I've practiced every day for many years instead of sounding clumsy as my fingers fumble over the wrong notes to a new song. And in every photography workshop, I meet beautiful women who express similar desires. They want their photos to be great, immediately great. But, as Julia Cameron wisely writes in the The Artist's Way, "You must be willing to be a bad artist. Give yourself permission to be a beginner. By being willing to be a bad artist, you have a chance to be an artist, and perhaps, over time, a very good one." We must start from where we are, at the beginning.

Learning a new art not only stretches our creativity but comes up against all our fears and doubts that we aren't good enough or creative enough to keep trying. When you hear those critical voices, I want you to remind yourself that true creativity is about venturing into the dark. It's as if we are mining into the core of our hearts for gold we believe exists—for the well of fresh inspiration that has yet to be struck. And this process, the creative process, is often messy, but it's incredibly rewarding.

When you encounter those days when the camera doesn't seem to capture anything worth saving, and your family is tired of you trying, take a deep breath. Maybe even call it quits for the day, but start anew the next. Not only are there hard days but there are also great days when your camera begins to feel like an extension of your body and you intuitively change your camera settings without having to think about lighting or composition. If you continue to practice, I can tell you with full confidence that you will

reach these days. But it begins with starting from where you are. Turn a deaf ear to the critical voices that say it isn't worth starting. You must protect your creative self as it begins to grow. You start by stretching rather than forcing.

This is just like yoga practice, when the first fifteen minutes of class is often painful when I realize how stiff I am. But as I continue to go through the practice, following my breath, I start to sink into the single moment. All the noise, distractions, and voices begin to fade. Photography reminds me so much of yoga. We can rush into taking photos, or we can pause. Find the story. Build a creative vision for how we want to capture our family's story. And then, lift the camera to take the shot.

As you walk through these forty photo recipes and experiment with all the photo tips and creative exercises in chapters 1 and 2, give yourself permission to start from where you are—to begin to stretch your own creative vision. Give yourself room to be messy and to try, fail, and try again. You will take countless photos. Some of them will be amazing, and others can be chalked up to experimentation. And when you aren't looking, you may notice your family leaning in, stretching to see what you're doing, trying their own creative ideas when no one is watching. By starting from where you are, and not judging or beating yourself up for not being somewhere else, you give your family permission to start, too. Imagine the pictures you will capture of your family when everyone is free to experiment with their creativity. Imagine how inspiring that will be to everyone else in your home. Imagine the legacy you'll create with your photos. Your family in pictures will live on for generations to come. It all starts with you being willing to be stretched.

Me Ra Koh

Psalm 126

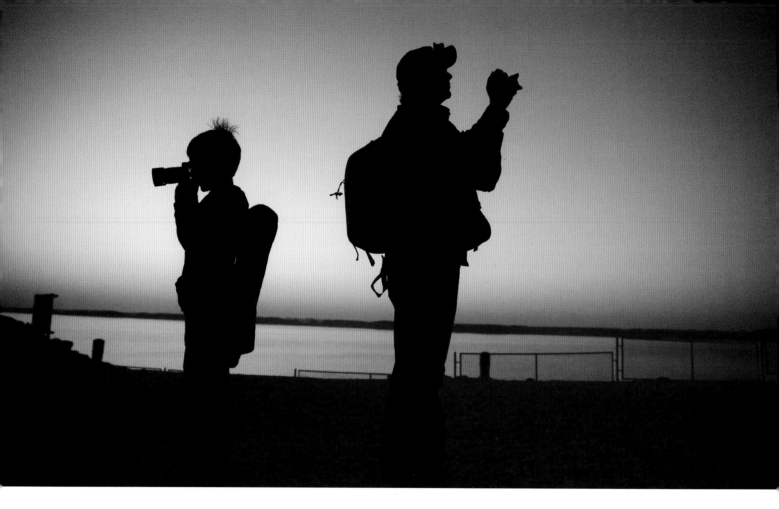

appendix
gearing up

ave you ever stood at the counter of a camera store and felt overwhelmed with all the choices? Or maybe you've gone online to look at the camera options and two hours later feel cross-eyed with specs and camera features that sound like a foreign language. What you are shooting—the type of stories you want to capture—directly impacts what type of camera gear to invest in. Whether you plan to spend $300 or $3,000, buying the right camera that best tells your family's story is an investment. Discover the pros and cons to a point-and-shoot or a DSLR.

choosing a camera

It's amazing how much technology continues to evolve. Since the publication of *Your Baby in Pictures*, there are so many new camera features available that weren't available two years ago. Some of those features improve our picture-taking and are game changers to the industry, and some features are what I call "bells and whistles" that are not necessary. If you already have a camera that you're happy with, you may just want to skim this section for future purchases. But if you're looking to buy a camera, the type that you choose is a big decision that will impact your photography for years to come. Let's look at some key benefits to point-and-shoot (P&S) models versus the heftier DSLR.

Consider the pros and cons of different camera models before making your purchase. Point-and-shoots and DSLRs used to be the only two options. Now there's also a hybrid, which is a DSLR in performance but the size of a point-and-shoot to fit in your purse!

things to consider when buying a point-and-shoot

Point-and-shoots can often get a bad rap because they aren't "real" cameras. However, in today's market, there are amazing features that point-and-shoot models offer. How do you know which one to choose? Look over the tips below when shopping for the model that will best fit your needs. But keep in mind that even though point-and-shoots are much more advanced in technology, they still hit a ceiling when it comes to their ability to control exposure, create soft-focus backgrounds, and, most of all, have enough speed to capture moments of low light. You may want to consider the new hybrid cameras that are discussed in the sidebar on the next page. But if a point-and-shoot is what your pocketbook can afford, look for these features to help you choose the best one.

TEST SHOOT. Ask the salesperson if you can step outside to take a few test shots with several different brands of point-and-shoot cameras. In fact, ask the salesperson to be your model. Have the salesperson stand in the same place for every photo. Take a few photos with different camera brands to see which camera produces the best skin tones. Keep in mind that this exercise won't work as well inside the store because of the florescent indoor lighting.

PRINT SIZE AND MEGAPIXELS. One of the top selling points for a point-and-shoot camera is the issue of megapixels; however, the whole subject can get confusing for many people. Megapixels are directly connected to how big your prints can be without losing quality. Follow this breakdown to know how many megapixels you need: 5MP (megapixels) = 8 x 10 SP (sharp print), 8MP = 11 x 14 SP, 13MP = 1 3 x 19 SP (however this is an odd size to print or frame), 15MP = 16 x 20 SP. If you know that you share most of your images digitally (sending in an e-mail, posting on Facebook, digital scrapbooking, and so on), then somewhere between 5MP and 8MP is plenty.

OPTICAL ZOOM VS. DIGITAL ZOOM. With most point-and-shoot cameras, you can't switch lenses, so you'll want one that has the ability to zoom in for close-ups and zoom out for wider shots. It's important to look specifically for optical zoom rather than digital zoom, which leads to a lower-quality image.

DURABILITY. There are a number of weatherproof/water-resistant/waterproof point-and-shoot cameras on the market. Many of them even claim to withstand being dropped. Since we're talking about taking pictures of kids (those little hands can grab expensive things and drop them), it may be worth investing a few more dollars in one of these models if you know you are going to be poolside or at the beach.

FAST/CONTINUOUS SHOOTING MODE. With kids on the go, you want to make sure you have the option of choosing a fast or Continuous Shooting mode so that you can take multiple images per second. This may also be referred to as FPS (frames per second) by the camera manufacturer.

SCREEN RESOLUTION. The little screen on the back of your point-and-shoot is a big deal, because that's what you look at to determine the photo you're taking. Rule of thumb is to make sure your screen display is 2 ½ to 3 inches in size. This will be much easier on the eyes and, in turn, increase your chances of successful picture-taking.

HDMI OUTPUT. My husband always makes fun of me when I say "HDMI." Apparently, I don't say it the way guys say it. But, I get the purpose of this feature. If you want to view your images on your television screen, it's wonderful to have an HDMI output so that you can plug the camera straight into your TV to view your photos.

HD VIDEO. Most point-and-shoots now list video as one of their top features. The purpose of a point-and-shoot is to have a compact, easy-to-use camera option that can fit in your purse. Why not add an HD video feature as well? If video is at the top of your list for point-and-shoot features, look for FULL HD 1080/60p to get the best quality of fast recording with minimal, if any, playback distortion.

When family is moving around, you want to make sure your point-and-shoot has a form of Fast/Rapid/Continuous Shooting mode so that your camera fires at a decent pace. This won't be the speed a DSLR provides, but you will still catch the sweet variations that happen within a few minutes.

THE NEW HYBRID CAMERAS

There's a new option available to photo hobbyists and pros: it's referred to as the hybrid camera. If you ever dreamed of having all the technology of a DSLR in a camera that's the size of your point-and-shoot, you're thinking of the hybrids. Here are a few star features that are making photographers fall in love with hybrids!

SMALL SIZE, GREAT PERFORMANCE. The hybrid camera is as small as a point-and-shoot, but the sensor is big—the same size as many DSLR sensors—which means beautiful detail and enlargement quality that fits in your purse!

INTERCHANGEABLE LENSES. Instead of being limited to a point-and-shoot's built-in lens, you can change lenses with the hybrids and achieve better aperture and shutter speed results.

SPEED. Whether we're talking about the autofocus speed or how many photos you can shoot per second (FPS), the hybrids are performing at top speed.

HD VIDEO. The speed and big sensor both affect the video component, giving you amazing, high-resolution video.

things to consider when buying a dslr

Owning a DSLR opens up a world that's inaccessible with only a point-and-shoot. As your comfort with and understanding of your DSLR grows, you will have the opportunity to control all the settings! But (and this is a big but) without understanding how to get off Auto mode, or what I refer to as going "beyond the green box," your DSLR can end up taking photos that look like those of a point-and-shoot. To avoid this expensive frustration, consider the tips below as well as the photo recipes throughout the book.

TRANSLUCENT MIRROR TECHNOLOGY. This new feature in DSLRs is a game changer for the photo industry. Gone are the days of trying to guess whether a faster shutter speed will make your image brighter or darker. You can now look at the LCD display on the back of your camera, or Live View, and as you speed up or slow down your shutter speed, you watch the Live View become darker or brighter. As you change your ISO, you can also see the image become darker or brighter on your Live View. Basically, what you see in the Live View is exactly what your photo looks like. You almost have to see this in action to believe it. It is amazing!

IMAGE STABILIZATION. When taking pictures of kids indoors, we often end up with blurred motion as a result. This blurred motion is because we don't have enough light and either our hand moved or the subject moved. But what are the odds of kids moving when you take their picture? Super High! Solution: An image stabilizer. This specific feature uses motion sensors to make adjustments for low light so you get as little motion blur as possible. Ask your local camera store to show you camera models that have Image Stabilization *built in to the camera body* so that you have it for every shot instead of having to spend extra money on Image Stabilization lenses.

ISO PERFORMANCE. If you know you will be shooting a lot in low-light situations (indoors, cloudy days), you may want to invest in a DSLR that is more than a thousand dollars. The ISO in the entry-level DSLRs (typically under a thousand dollars) tend to show noise/graininess at ISO 800, which dilutes the image quality. I've met countless moms who are frustrated with this, because every time they take pictures in their home, they have to be at ISO 800. If you know you will be shooting indoors, the more expensive DSLR with higher ISO ranges will make a night-and-day difference. Some DSLR models boast ISO 128,000! This means that your ISO 800 indoor photos won't detect any noise at ISO 800, even 3600, and most likely higher.

IS THE MENU USER-FRIENDLY? As you examine the different DSLR brands, ask yourself whether the menu is intuitive and easy to navigate. Or do you find yourself fumbling around, unable to locate the settings you need? Having the ability to react fast will make all the difference when you need to change your settings before the special moment is gone.

WEIGHT AND SIZE. Camera manufacturers recognize more than ever the increasing number of people for whom weight is a factor when buying cameras. If possible, handle the DSLR you are considering buying. Does it feel heavy or too light? Does the size of the camera fit well in your hands? Eventually, you will want

your DSLR to feel like an extension of your body. This is why your comfort level with the weight and size is so important. If you have to choose between a beefier camera body or a new lens, go with the smaller camera body and invest in the new lens.

My two workhorse lenses are the 24—70mm F, f/2.8 and the 70—200mm F, f/2.8. Both give me the option to create a buttery blurry background, but one is for taking family portraits, and the other is for when I'm on the sidelines at one of my kids' sporting events. Different lenses serve different purposes. To know what lens is best for you, consider the types of stories you want to capture of your family.

what type of lens to buy

Owning the right camera gear is another key factor in setting your photos up for success. Your choice of lens can make all the difference between a snapshot and an engaging storytelling photo. But different lenses serve different purposes. The first step is to identify what you enjoy shooting the most.

When your child was a baby, you could easily get in close with the fixed 50mm, Ff/1.8 lens that we discussed in *Your Baby in Pictures* . That lens is a great choice for getting in close to capture your subject with a softened background. But as your baby becomes a child, you can't always get in as close—especially if you want to go unnoticed when you're shooting. And when you want to take a group photo, the ability to have a low f-stop isn't as important as fitting everyone in the photo.

It's important to determine the focal length that you'll be shooting at using most. Do you see yourself zooming in from a distance on the sidelines of a soccer field? Or do you see yourself wanting shots that are more portrait-like, taken six feet away or closer to your subjects? The following are answers to common questions moms ask me when purchasing a lens. These tips will set you up for success when you're ready to invest.

SAY "NO THANK YOU" TO THE KIT LENS

If possible, buy the camera body but pass on the kit lens that comes with it. The kit lens isn't worth much and will make you wonder why you upgraded from your smartphone or point-and-shoot. In fact, the lens is so important that if you have to choose between buying a nicer camera body or a separate lens, invest in the lens. There will be a new camera body with the latest bells and whistles every year, but the glass used in the more expensive lenses will still amaze you with beautiful results year after year.

ZOOMS ARE BOTH WIDE ANGLE AND TELEPHOTO LENSES. Over the years, I've met numerous people who are confused by the term *zoom*. We often think of a zoom lens as a telephoto lens that helps us see something from a distance. But the term *zoom* is simply refersring to the fact that you don't have to move your body to get closer to your subject. Instead, you can zoom in. This means that a wide-angle lens (a lens that can see a lot from your right to your left), is also a zoom. When you're shopping online, don't be thrown off if you see a telephoto lens and wide-angle lens both under the zoom category.

IS THE BIGGER ZOOM BETTER? It's not necessarily better. The person at the camera shop will often try to sell you on the biggest zoom lens they have, by saying it provides the most versatility. Meaning you can be far away and zoom in, or you can zoom out when you're close to the subject. But if you like buttery blurry backgrounds, you want to look for a lens that has an aperture of f/2.8 versus f/3.5-5.6. This range in f-stops (f/3.5-f/5.6) means that the closer you get to your subject, the less blurry the background will be. This is a detail that many beginners don't understand, and $500 dollars later, they are frustrated with their photo results.

Moms often ask me what my first choice of lens would be. Without hesitation, I say the 24-70mm, f/2.8 lens. Notice how the f-stop notation isn't a range like f/3.5-f-5.6. Instead, it' is just f/2.8, which means that no matter how much I zoom in or out, I can always dial down to f/2.8, which gives me that buttery blurry, soft background. At 24mm, I can also capture great group photos or landscapes and scenery. But I can also zoom in to 70mm for a more closeup, portrait style looking photo. You'll notice that some of these lenses are $1500 plus and some are $400 for every major brand (SONY, Nikon, Canon). The price difference is based on the quality of glass. There's just no comparison between the quality of color and light that you get with a $1500 lens versus what you get with the cheaper version from a thirdparty manufacturer. But in the beginning, I started with the cheaper, thirdparty lens (and got great results for the level I was at) until I knew for sure my interest in photography was here to stay; and then I grew into $1500 plus investments on lenses.

My second lens of choice is the 70-200mm f2.8. Once I had the 24-70mm, my next purchase was the 70—200mm, f/2.8. Now with this lens I could zoom in to my subject(s) from far away, and my f-stop still stayed low at f/2.8 (which gives me all that buttery blur I love). This is a great lens if your kids are involved with sports or activities that force you to stand at a distance, like soccer, gymnastics, baseball, dance performances, etc., and so on. This lens also comes in handy when your baby becomes a toddler who resists having his photo taken, and capturing him without being noticed is vital.

index